IMAGES
of America

HULETTS LANDING ON LAKE GEORGE

On the cover: This photograph shows a group of tourists posed in front of the Huletts Hotel in the summer of 1959 before the hotel was torn down in November of that year. Their smiles capture the relaxed, welcoming, and fun atmosphere of people enjoying their vacation. Families with children have always been a part of the Huletts landscape. (Courtesy of Kapusinski collection.)

IMAGES
of America

HULETTS LANDING ON LAKE GEORGE

George T. Kapusinski

ARCADIA
PUBLISHING

Published by Arcadia Publishing
Charleston SC, Chicago IL, Portsmouth NH, San Francisco CA

Printed in the United States of America

Library of Congress Catalog Card Number: 2007938169

For all general information contact Arcadia Publishing at:
Telephone 843-853-2070
Fax 843-853-0044
E-mail sales@arcadiapublishing.com
For customer service and orders:
Toll-Free 1-888-313-2665

Visit us on the Internet at www.arcadiapublishing.com

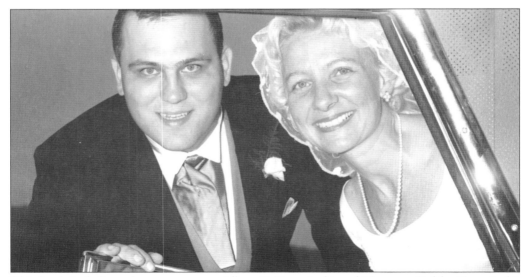

This book is dedicated to my parents, Albert T. Kapusinski and Margaret Eichler Kapusinski, shown here in 1963 in Huletts Landing on their wedding day. Both of them have passed on to me the "spirit of Huletts" in different ways. May the true "spirit" always be found there. (Courtesy of Kapusinski collection.)

CONTENTS

ACKNOWLEDGMENTS

I could not have completed this work without the assistance of many people. There are several people who paved the way for this book through their research and love for Huletts Landing.

To begin, as you will read in the introduction that follows, I continued the research of my mother, Margaret Eichler Kapusinski, who fostered in me the idea of writing a book about Huletts Landing. She assembled some of the material presented in these pages.

A special thanks goes to Lance DeMuro, whose love for Hulett history is unmatched and who opened his private collection, which took him over 20 years to acquire. I drew from Betty Ahearn Buckell's book, *No Dull Days At Huletts,* and my meeting notes with her from over 20 years ago. Heather Hulett Harvey provided me with invaluable research regarding the Hulett family.

Probably the most important person in helping me fill in missing facts from the last two centuries was Francis Borden, who has lived his entire life in Huletts Landing. The Borden family's contribution to the growth of Huletts simply cannot be explained in one sentence. Their hands have fashioned history as it was built.

I have had many guests and tourists to thank for their reflections, but one family's continuous rental streak of over 50 straight years can only be called the "Huletts version of Cal Ripken." Reginald and Connie Ballantyne have vacationed with their family continuously in Huletts for over 50 years and as of this writing have recently celebrated their 65th wedding anniversary. Their reflections over many years of friendship have made this book possible.

I would also like to thank the many owners and families in Huletts who remember that the key to unlock the spirit of Huletts Landing will always be how guests and tourists are welcomed. Do you remember your first visit to Huletts? If you are one who looks forward to the influx of many friends in the summer, and the joy and life they bring, then you will always be happy.

Finally, my family's contributions must also be noted. My brother Albert J. Kapusinski, who reopened the casino in 1989 after it was closed for 17 years, understood that for a community to be alive it must have life after dark and my brother Frank Kapusinski, whose love for law has contributed to my search of historic records, have both contributed in ways that they are probably unaware of. My father, Albert T. Kapusinski, has always been there to answer questions about Huletts or any other matter a son could ask.

INTRODUCTION

Lake George, has become a place of so much genteel resort, in connection with the Springs in Saratoga County, and the many points of public curiosity in this state, that it must be highly gratifying to the public to learn that a Steam Boat is to be built on that Lake, by a company of opulent and patriotic gentleman.

Houses of entertainment will be erected on that route, lines of stages established, and every exertion that the occasion shall warrant to establish the great thoroughfare for Canada and the north via Ballston, Saratoga, Glenn's Falls, Caldwell and Lake George, to Ticonderoga, on Lake Champlain. The distance will no than equal that of any other route, and no tourist, nor mere traveler on business, would hesitate to prefer the new route, when he considers the famed Medicinal Waters, the beautiful and romantic scenery of Lake George and its environs, which lie in his way. Besides, the road may be made as much better than the other, as a sandy and gravelly soil is preferable to clay.

The present road from Albany to Sandy-Hill, is at best not good, nor is it easily to be made so; while that from Sandy-Hill to Whitehall, has very justly acquired the reputation of being most intolerably bad. Indeed so numerous are the considerations that confer a decided superiority on this route, that we cannot but express our surprize its having lain so long neglected.

New-York Spectator, Wednesday, August 28, 1811

If you are reading this book, you probably know of Huletts Landing or perhaps you even live there. Nestled on the eastern shore of Lake George, with its dazzling sunsets and panoramic views of the Adirondack Mountains, its quiet charm and glistening beauty make it a special place in the hearts of many. The steamboat, as speculated in the article quoted above, did in fact play an important and crucial role in its development.

Why are people drawn back to Huletts Landing year after year while others return after long periods of absence? It is hard to define how Huletts Landing makes its call, but I have come to believe it does call people. It calls them in many ways: to rest and relax, to return to a simpler way, to experience nature, to look inward, and to make friends. Its call is unique, but it always gives a joy and happiness to those who experience it.

Parents have told me they use their annual vacation to Huletts as a motivator to their children to behave and get good grades. A simple "if you don't improve, we're not going back to Huletts"

is enough to correct a child who has experienced its summer days. Others have said their view of heaven is that "it would be a bright day in Huletts forever."

What makes Huletts so special? My parents would always say that ultimately it was the people who made Huletts special. As I have grown older, I have come to the firm conclusion that my parents were right. However, while I had seen pictures and heard stories, I also realized how little I really knew of the people who made Huletts Landing the place it is. When I started to look at the actual historical record of what I thought I knew, I realized I knew very little.

My mother long ago began collecting memorabilia and photographs that she wanted to make into a book when she retired. Unfortunately, she never had the chance because she died relatively young, having been stricken by cancer. I once read that for anyone losing their mother, it is akin to losing your biggest fan in life, the person who will always be at your play or game, the person always cheering for you. Having thought about this while also continuing my mother's collection over the years, I thought it was the least I could do for her to make her idea a reality.

I started my focus on the Hulett family because there is a good deal of interest in who they were and how they originally shaped the land. While much of who they were has passed from existence, I was able to learn a lot about them. They were hardworking, industrious, and religious people. While Philander Hulett was the last Hulett who lived in Huletts Landing, I was able to locate Hulett descendants and learned that tragedy, unfortunately, is part of their story.

This work is by no means a definitive history of Huletts Landing. It is an attempt to share what I have learned about those who have walked and worked on its shores and to give life in these pages to those who transformed this piece of land into the Huletts Landing that so many love and whose call to return will hopefully always be heard.

One

ORIGINS

A good place to start a book about Huletts Landing would be to begin with how the original Hulett family arrived here. In researching this book though, conflicting stories about how this happened were uncovered. This is what the author has been able to piece together from various accounts.

Evidently, the Huletts were French Huguenots driven from France during the persecution who ended up in Providence, Rhode Island, before they separated along different family lines. Some Huletts moved to Vermont, and others moved to Connecticut.

What is known is that David Hulett died on October 3, 1832, in Huletts Landing. While it is believed that he was 70 years old when he died, information was discovered listing him as one of three individuals over 70 years old in Dresden in 1830, which would have made him at least 72 years old in 1832. To further complicate what his age may have been, present-day Hulett descendants provided two dates that he could have been born: February 22, 1758, or February 22, 1762.

He was born in Killingly, Connecticut, which is amazingly close to the town of Putnam, Connecticut. He is known to have served as a private in Captain Dixon's 3rd Company of the 3rd Battalion of Gen. James Wadsworth's brigade. This was one of seven battalions commanded by Brig. Gen. James Wadsworth after Gen. George Washington called for reinforcements and the Connecticut Assembly responded by ordering their creation. The 3rd Battalion of Wadsworth's brigade was commanded by Col. Comfort Sage and consisted of eight companies. The 4th Company consisted of volunteers from the Bolton-Tolland area and was commanded by Capt. Jonathan Birge.

Wadsworth's brigade fought in the battle of New York in September 1776, resisting a full-scale invasion of British and Hessian forces under General Howe. What is interesting to note is that during a period of three years, they fought almost exclusively in large areas of Upstate New York. It is particularly interesting that three of the names associated with different areas of Lake George today, Bolton, Putnam, and Huletts, share a common thread to the names and towns associated with Wadsworth's Connecticut brigade.

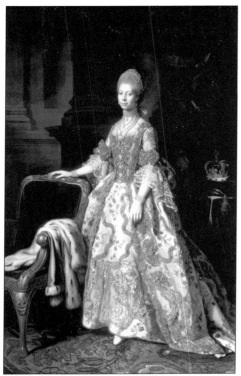

Charlotte County, named in honor of Queen Charlotte, wife of King George III of England, was formed in 1772 from part of Albany County. It contained a large portion of the present state of Vermont. It would not be until April 1784, that the legislature passed an act changing the name of Charlotte County to Washington County in honor of Gen. George Washington. This portrait of Queen Charlotte was created by Nathaniel Dance about 1769.

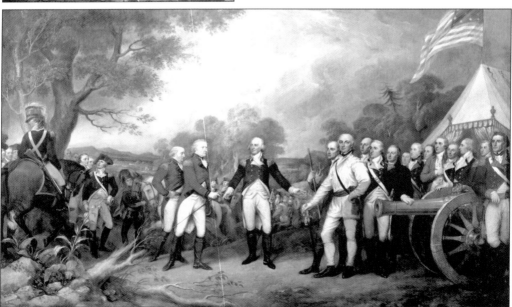

Accounts from Hulett descendants put both David and Daniel Hulett at the Battle of Saratoga in 1777 where they showed great heroism on the field of battle. One was shot in the neck but refused to leave the field saying he would shoot at the British as long as he could just kneel. Research is complicated because six Hulett brothers from Killingly Connecticut fought in the Revolutionary War. Seen here is *The Surrender of General Burgoyne at Saratoga* by John Trumbull.

Records indicate that Huletts were living in what would become present-day Huletts Landing as early as 1804, when Thomas Jefferson was president. Accounts differ on how they arrived. Two theories are that New York made attempts to resettle soldiers within its borders, fearing conflict would continue in the new nation, and that some noncommissioned officers and privates were paid in land grants by the cash-starved new legislatures through necessity. Seen here is *Thomas Jefferson* by Charles Wilson Peale, 1791.

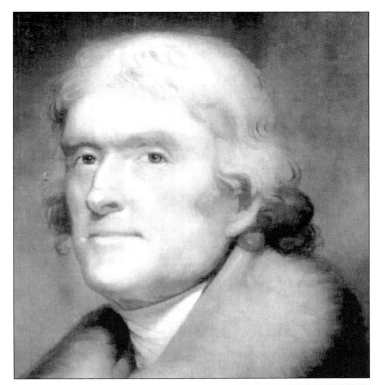

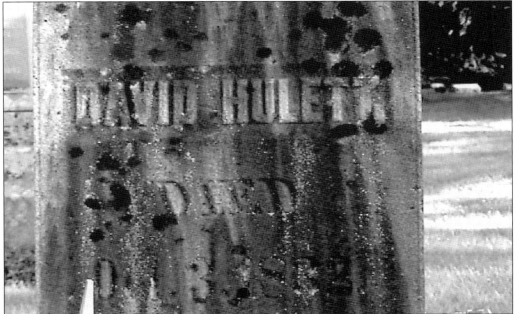

David Hulett's tombstone from 1832 makes no reference to his tragic death. Taking his two young grandsons Arnold and Alonzo rattlesnake hunting on a sunny October day by rowboat at Deer's Leap across the lake, David Hulett became pinned by a sliding bolder. When help arrived, Hulett's leg was amputated, and he died from shock shortly thereafter. (Courtesy of Kapusinski collection.)

| SCHEDULE I.—Free Inhabitants in *Dresden* in the County of *Washington* State of *N. York* enumerated by me, on the *5th* day of *Sept.* 1850. *Wm. F. Blanchard* Ass't Marshal. | | | | | | | | | | | | |

Dwelling-houses numbered in the order of visitation.	Families numbered in the order of visitation.	The Name of every Person whose usual place of abode on the first day of June, 1850, was in this family.	Age.	Sex.	White, black, or mulatto.	Profession, Occupation, or Trade of each Male Person over 15 years of age.	Value of Real Estate owned.	Place of Birth. Naming the State, Territory, or Country.	Married within the year.	Attended School within the year.	Persons over 20 y'rs of age who cannot read & write.	Whether deaf and dumb, blind, insane, idiotic, pauper, or convict.	
1	2	3	4	5	6	7	8	9	10	11	12	13	
41	41	Harvey Hulett	58	M		Do	3000	Conn					24
		Olive "	53	f	✓			Vt					25
		Alonzo "	30	M		Do		N York					26
		Philander "	24	M		Do		"		—			27
		Emeline "	24	f				"		—			28
		Mary A. Rockwell	15	f				"					29

This page is from the 1850 census for Dresden, where the descendants of David Hulett are recorded. The entire value of the Huletts' land holdings was valued at $3,000 in 1850. Harvey Hulett would complete a term as Dresden town supervisor in 1850.

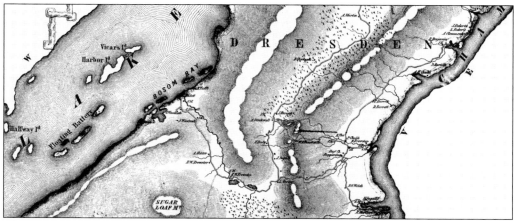

This map of Washington County, prepared from surveys by Morris Levey in 1853, indicates that the area was called Bosom Bay before 1874. The name changed in the 1870s, when Philander Hulett built the steamship landing and mail and supplies for the area were delivered by boat. Later this steamboat landing became critical in developing the area as a tourist destination. (Courtesy of Washington County Archives.)

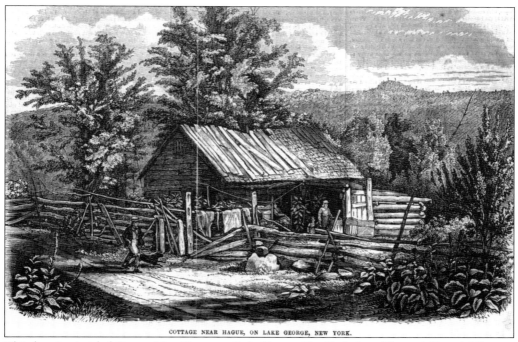

COTTAGE NEAR HAGUE, ON LAKE GEORGE, NEW YORK.

This drawing is titled *Cottage Near Hague, on Lake George, New York,* from *Gleason's Pictorial-Boston,* on Saturday, September 23, 1854. The Huletts, like much of the population of the surrounding area, survived by farming. This consisted of tending to animals such as pigs, chickens, or cows and growing different crops like wheat, rye, and even hemp to make rope. Fruits and vegetables were stored in a root cellar. The article accompanying this picture referred to the house depicted as a "peasant home" on a "romantic spot on Lake George." (Courtesy of Kapusinski collection.)

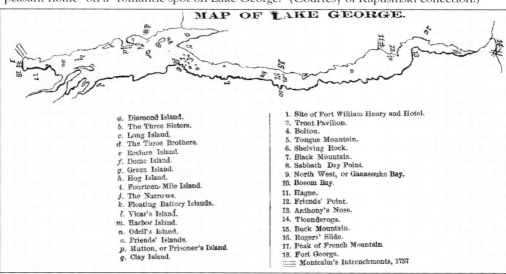

MAP OF LAKE GEORGE.

a. Diamond Island.
b. The Three Sisters.
c. Long Island.
d. The Three Brothers.
e. Recluse Island.
f. Dome Island.
g. Green Island.
h. Hog Island.
i. Fourteen-Mile Island.
j. The Narrows.
k. Floating Battery Islands.
l. Vicar's Island.
m. Harbor Island.
n. Odell's Island.
o. Friends' Islands.
p. Mutton, or Prisoner's Island.
q. Clay Island.

1. Site of Fort William Henry and Hotel.
2. Trout Pavilion.
4. Bolton.
5. Tongue Mountain.
6. Shelving Rock.
7. Black Mountain.
8. Sabbath Day Point.
9. North West, or Ganasouke Bay.
10. Bosom Bay.
11. Hague.
12. Friends' Point.
13. Anthony's Nose.
14. Ticonderoga.
15. Buck Mountain.
16. Rogers' Slide.
17. Peak of French Mountain.
18. Fort George.
====== Montcalm's Intrenchments, 1757

This map from the 1869 book *Lake George* by B. F. DeCosta indicates that the area was called Bosom Bay before 1874 (note 10 on map). DeCosta chronicled his many stops by steamboat, but before 1870 he refers to the area only as the steamer passes by, indicating that the steamship did not stop there at that time.

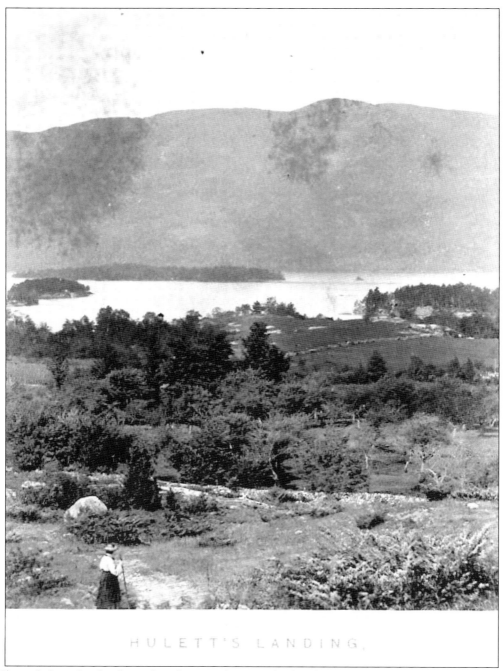

HULETT'S LANDING.

This is believed to be the earliest known photograph of Huletts Landing, around 1869. What is unique about this is that it comes from a one-of-a-kind photographic album compiled by Seneca Ray Stoddard. The actual photograph is attached and bound by a paper frame where the words *Hulett's Landing* appear. It is not a printed reproduction. The actual photograph was scanned from inside the album, and the paper frame was included. This original photograph is the rarest of all, capturing Huletts Landing in its infancy. (Courtesy of Lance DeMuro.)

Two

PHILANDER HULETT AND THE STEAMSHIP

As a young man, Philander Hulett must have grown accustomed to seeing the steamship pass every day with tourists and supplies. However, there would have been one problem for the Hulett family. The steamship did not stop. It continued past the area where they lived and would land farther north on the other side of the lake.

To change this, two things needed to happen. First a steamship landing had to be constructed, and second, there had to be a reason for the Lake George Steamship Company to stop. Tourism was beginning to flourish in the Adirondacks, and any industrious person would have realized the importance of having a stop on their property along the route.

The materials to build a great dock would have been plentiful on Philander Hulett's property. Timber was abundant, and rocks protruded everywhere. There was an ideal site where the depth of the lake could accommodate a large steamer at the end of one peninsula. It would be an ingenious marriage that would provide a better way of life for an industrious, hardworking man.

The Lake George Steamboat Company in 1870 had started transporting mail after entering into a contract with the U.S. government. This presented a unique opportunity. If a post office could be constructed next to the new dock and the farmhouse could be enlarged to accommodate the tourists the steamship would bring, there would be two reasons for the Lake George Steamboat Company to stop at this site. Work began very quickly.

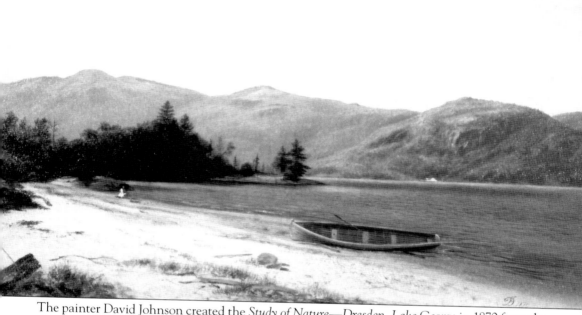

The painter David Johnson created the *Study of Nature—Dresden, Lake George* in 1870 from the shoreline facing west across the lake toward Deer's Leap. He captures the very area across the lake where David Hulett died in 1832 with a small boat in the foreground. He also captures the new steamship chugging up the lake. While the area where the steamship would eventually land is just outside the area captured by the painter, historical records indicate that the steamship did not stop here in 1870. Huletts Landing would not be so named without the creation of the steamship landing that Philander Hulett would construct. (Courtesy of the Albany Institute of History and Art.)

The original application to establish a post office in 1874 is the first known historical document where the area is designated as Huletts Landing. It is significant for numerous reasons. It designates Philander Hulett as the applicant for the position of postmaster, and it gives clues to life in 1874. The Lake George Steamboat Company in 1870 had started transporting mail after entering into a contract with the United States government. It is believed that in order to schedule a stop at the new location, the Lake George Steamboat Company wanted either a post office or tourism facility to be present. The steamship ran daily from Caldwell (Lake George Village) to Ticonderoga. (Courtesy of the National Archives, Washington, D.C.)

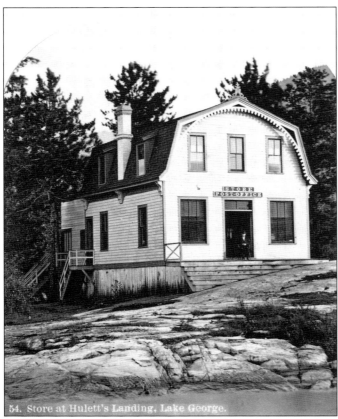

54. Store at Hulett's Landing, Lake George.

This is a picture from 1875 of the first store and post office and possibly the only picture of Philander Hulett. The original post office was located adjacent to the steamboat landing at the end of present-day County Route 6 and included a store. The newly constructed building was photographed, and the man sitting in front attired in a suit and fedora could be Philander Hulett, the first postmaster. He would die in 1883 after selling his property to businessman John W. Hall. (Courtesy of the Chapman Historical Museum.)

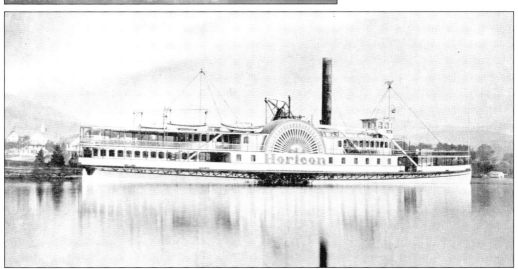

The new steamship *Horicon I* was an impressive vessel. While it was originally put in service in 1877, it would not be retired until 1911. It was 195 feet long with a beam of 30 feet and a gross weight of 643 tons. It was capable of traveling 20 miles per hour. Seen here docked in Lake George Village, it was the biggest boat that had ever sailed on Lake George in 1877. (Courtesy of the Lake George Steamboat Company.)

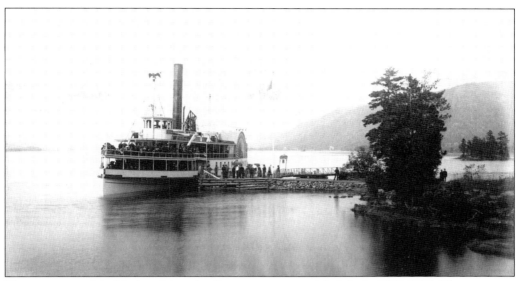

The new steamship *Horicon I* is unloading passengers and freight in 1877–1878. The new post office and steamship landing would bring tourists and vitality to the area. Seen here docked at the new steamship landing, the *Horicon* would bring passengers, tourists, freight, supplies, and mail. The dock at Huletts could only accommodate the front half of the ship. (Courtesy of the Chapman Historical Museum.)

Mr.

You have at this station———————lbs. of freight/express on which there are charges of———————————, and which we will be pleased to deliver after charges are paid.

DOCKMASTER,
HULETT'S LANDING.

A freight slip alerts a resident or guest that freight had arrived and was waiting to be picked up. The name and date on this actual slip are illegible due to fading and age. However, it clearly can be attributed to the dock in Huletts Landing. (Courtesy of Lance DeMuro.)

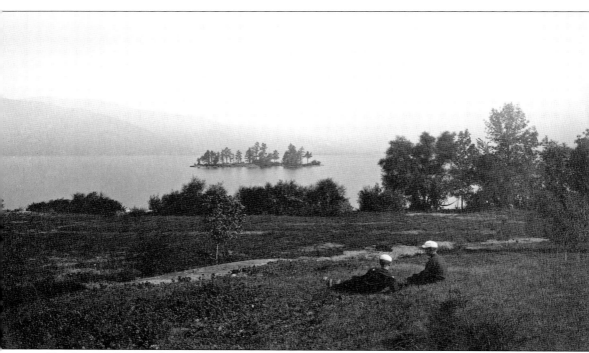

Two boys with white hats relax in 1878 where the volleyball court is located today. While these two boys' names are unknown, they embody the spirit of rest that so many would come to Huletts to find. Many people throughout the years would enjoy the same view looking north over Huletts Island. (Courtesy of the Chapman Historical Museum.)

Three

TOURISM FLOURISHES AND THE FIRST HOTEL

Part of Philander Hulett's property would be sold to businessman John W. Hall, but the bulk of the real estate would pass first to C. W. Wentz, an executive with the Delaware and Hudson Railroad, next to entrepreneur Henry W. Buckell, and finally by the early part of the 20th century to William H. Wyatt, an owner of hotels. All of these successive owners saw their first and primary role as marketing the property as a tourist destination.

Improvements were always being made to make the stay in Huletts a fun and relaxing experience. Developments in society at large played an increasing role in how tourists went about spending their vacation time.

The first tourists arrived in their best clothes for a vacation where they looked out at the lake but did not take a step into it. Their idea of relaxation centered around breathing the clean mountain air and enjoying the natural surroundings. Swimming did not become popular until later.

Advertisements from this period focused on getting the tourists out of the city and showing them how relatively easy it was for them to enjoy the country. They also focused on the fun activities going on. Today one would consider their travel experience anything but easy. Travel to Huletts Landing during this period entailed long periods on the train, carriage, and steamship, and when tourists arrived they were completely exhausted. Needless to say, this did not stop them from coming.

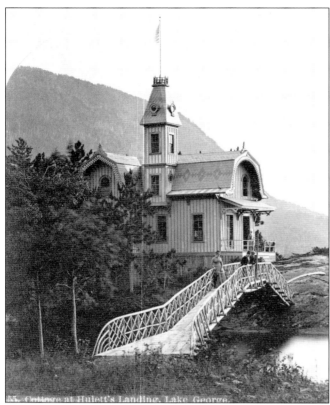

The original Lakeside Inn, as seen in 1877–1878, was a boardinghouse on the peninsula directly south of the steamship landing. Built by Whitehall businessman John W. Hall after purchasing one acre from Philander and Emeline Hulett in November 1873, it was originally constructed as a Victorian cottage. The bridge was necessary because the area between the two points was swampy and difficult to traverse on foot. (Courtesy of the Chapman Historical Museum.)

This is one of the earliest known pictures of the Hulett farmhouse looking in from Narrow Island in 1880. The original Hulett farmhouse is the large structure that occupies the hill. The building immediately to the right was constructed for the first tourists to stay and would later be incorporated into the first Huletts Hotel. The dining room is the low building to the right of the gazebo with the flagpole. The dining room was located where the tennis courts are today. (Courtesy of Lance DeMuro.)

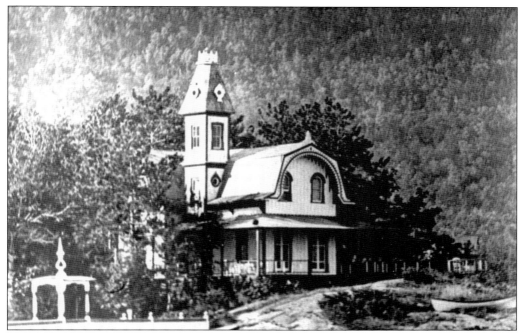

The original Lakeside Inn was on the peninsula south of the steamship landing in 1890 with a new bridge now evident. The bridge between peninsulas is clearly different than the one that was present 12 to 13 years earlier. Was the original bridge destroyed by a storm or was it rebuilt because of tourism demands? Some facts have been lost to history. (Courtesy of Lance DeMuro.)

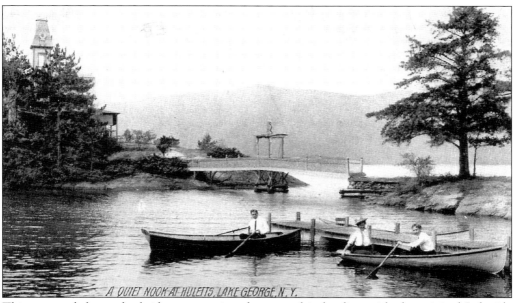

This postcard shows the bridge connecting the steamship landing with the original Lakeside Inn in 1890. It appears that the white boat in the lower right of this postcard is the same that appears in the lower right of the preceding photograph. (Courtesy of Lance DeMuro.)

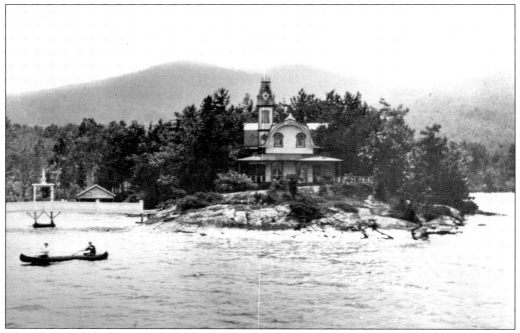

This photograph of Lakeside Inn was shot from the deck of the steamship. This picture was not taken from water level. Because the steamship would have been the only vessel with a deck that high off the water and because it was also taken from the path that the steamship would take to arrive or depart from Huletts, it appears this picture was shot from the deck. (Courtesy of Lance DeMuro.)

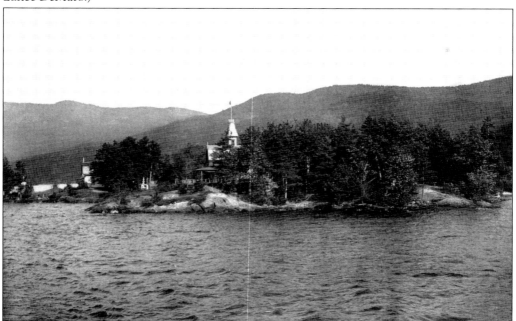

Another view looks northeast in 1895 toward Lakeside Inn and the original post office. The remoteness of the area stands out in this photograph. (Courtesy of Lance DeMuro.)

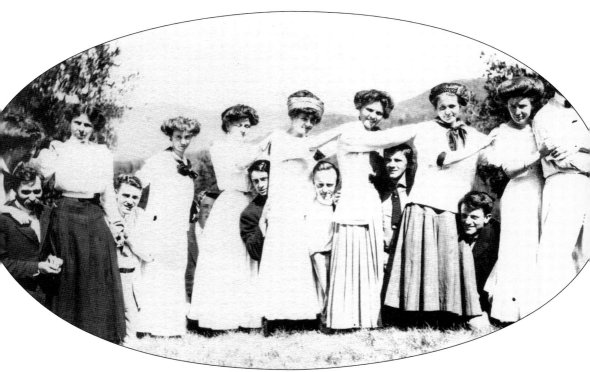

Henry W. Buckell (far left), proprietor of the Hulett House and Lakeside Inn, kneels with a group of performers for the hotel. His obituary in 1954 states, "If one were to attempt to sum up Mr. Buckell in a word, it would probably be individualist." It continues, "He believed in the little red school house, in thrift, in hard work, in doing the best you can with what you have until you are in a position to do better, and in self reliance. Some of this sounded like strange talk these days but it was a regimen that seemed to have served Mr. Buckell well. He practiced all of it until the day he died." (Courtesy of Kapusinski collection.)

Fireworks ! Where ?

AT THE

✠——Hulett's Landing Hotel

EVERY FRIDAY NIGHT.

Hops every Thursday. Progressive Euchre every Tues-day. Free Excursions Wednesdays and Saturdays. Straw Rides. Corn Roasts, Musicals, Baseball, Concerts, etc. Something to amuse you every day of the season.

We shall have vacant rooms after the 20th of August and will make a rate of $1.50 per day or $10 per week to any one presenting this sheet at the office. The house is known as the gayest place on the lake, and the situation is most romantic and picturesque.

Henry W. Buckel, Prop.,
Hulett's Landing, N. Y.

Seen here is one of Henry W. Buckell's original advertisements from 1898. The more common activities of today, such as golf, tennis, swimming, and boating, are not mentioned. The focus was on activities where the natural environment could be enjoyed. (Courtesy of Kapusinski collection.)

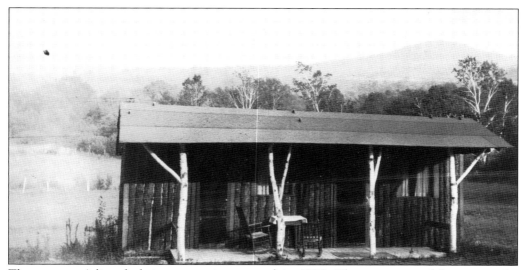

The cottage Adirondack is seen as it appeared in 1900. The cottages and houses in the surrounding area sprang from very humble beginnings. The area behind Adirondack, where many houses are located today, was nothing more than a grassy field in 1900. (Courtesy of Kapusinski collection.)

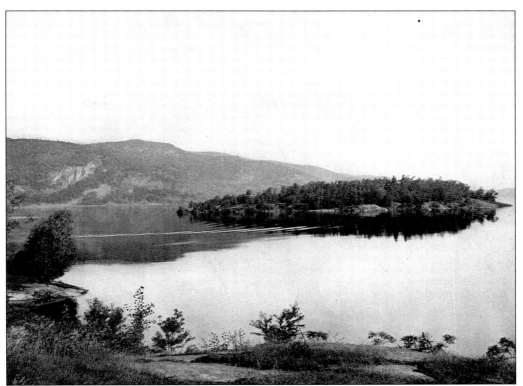

This view is northwest toward Burgess Island in 1900. Burgess Island is named after the Burgess family of Huletts. Emeline Burgess was 24 years old when she married Philander Hulett on May 30, 1850, and was 70 when she died on February 15, 1897. The State of New York would not install docks for campers until the 1940s. (Courtesy of Kapusinski collection.)

This stationary was used by Henry W. Buckell from approximately 1900 during his ownership of the Hulett House Hotel. While the contents of the letter are unreadable, the printed letterhead remains clear. (Courtesy of Lance DeMuro.)

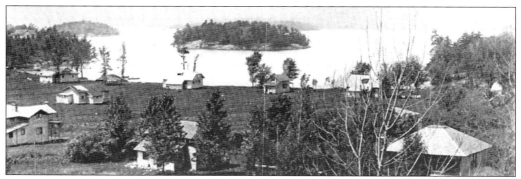

A picture of some of the original cottages looks out toward Burgess Island. By 1900 there were approximately 25 cottages associated with the hotel. (Courtesy of Lance DeMuro.)

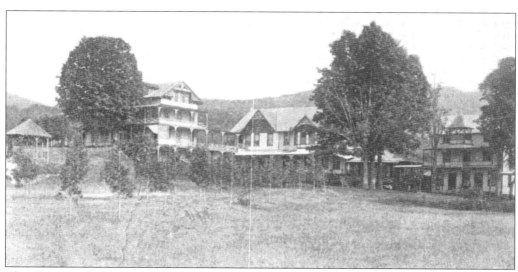

This photograph from 1900 shows the progression and expansion of the Hulett farmhouse into what would later become the first Hulett's Hotel. Notice that the gazebo overlooks the beach. (Courtesy of Kapusinski collection.)

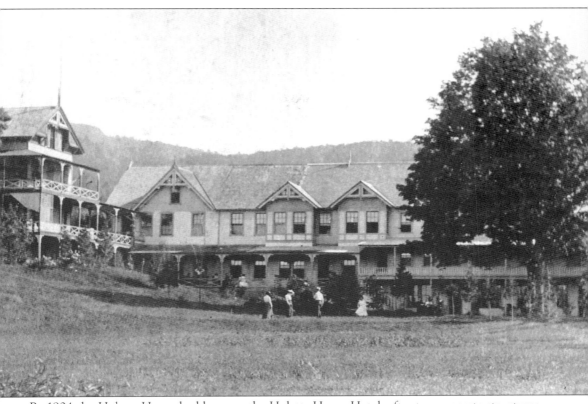

By 1904 the Huletts House had become the Huletts House Hotel, after two separate structures were joined in the middle. Guests can be seen enjoying themselves on the lawn. Notice the clothes guests relaxed in. The tennis courts were not yet present. (Courtesy of Lance DeMuro.)

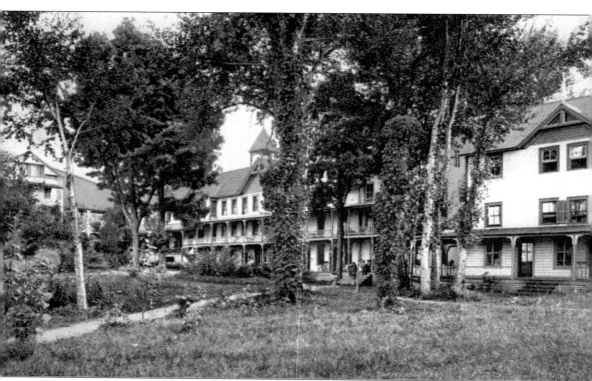

This postcard from 1912 depicts the first Hulett's Hotel; it was shaped like an L, with the original farmhouse part sitting on the hill at an angle to the rest of the structure. By 1912 the Huletts Hotel could accommodate approximately 200 guests. The entire structure would burn to the ground on November 14, 1915, leading the district attorney to charge the hotel's owner, William H. Wyatt, and an acquaintance, John Sharpe, with arson. (Courtesy of Kapusinski collection.)

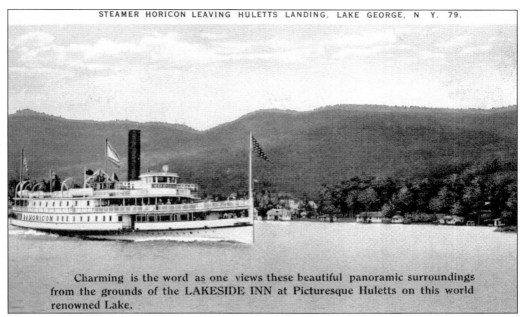

STEAMER HORICON LEAVING HULETTS LANDING, LAKE GEORGE, N Y. 79.

Charming is the word as one views these beautiful panoramic surroundings from the grounds of the LAKESIDE INN at Picturesque Huletts on this world renowned Lake.

This postcard is from the time period when Henry W. Buckell and William H. Wyatt were competing against each other for tourists. In 1913, Wyatt purchased the Huletts Hotel from Buckell. However, Buckell retained ownership of the Lakeside Inn. For the next few years they competed against each other for guests. This particular postcard would have been one produced by Buckell because it advertised only the Lakeside Inn. (Courtesy of Lance DeMuro.)

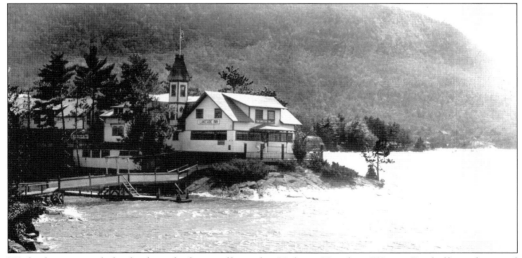

With the proceeds he had made from selling the Huletts Hotel to Wyatt, Buckell modernized and expanded the Lakeside Inn. The Lakeside Inn was an impressive structure, accommodating 50 guest at a time in 1914. (Courtesy of Kapusinski collection.)

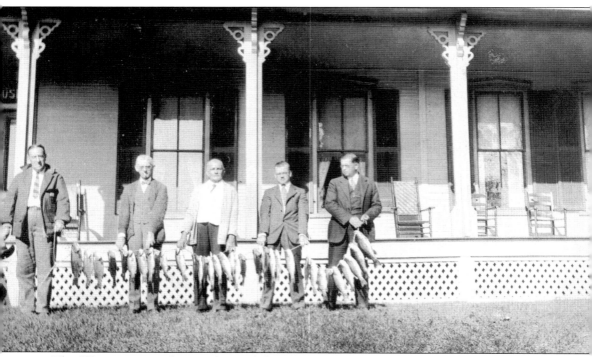

The Wyatts are standing in front of the original Huletts House Hotel in 1915. William H. Wyatt is seen standing in the center of the photograph, his son Arthur Wyatt is furthest to the right. The distinctive upper part of the columns are from the first Huletts Hotel. (Courtesy of Kapusinski collection.)

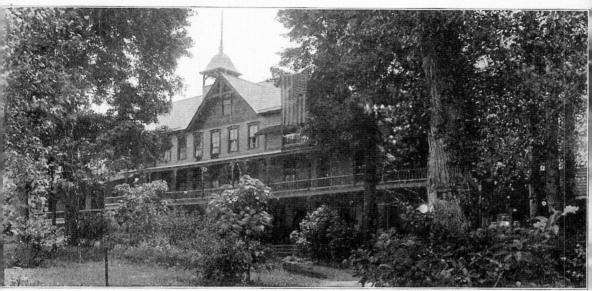

PICTURESQUE HULETT'S

ON LAKE GEORGE

W H. WYATT
OWNER AND PROPRIETOR

This is the last known photograph of the first Huletts Hotel before it burned down. William H. Wyatt and John Sharpe were charged with arson after the first Huletts Hotel burned down and William H. Wyatt collected $37,000 in insurance money. The prosecutor charged that after the summer of 1915 the two men met in Albany and planned the fire. It was alleged that Sharpe, traveling under an assumed name, registered at Clemons with a woman and then proceeded to the Huletts Hotel. Sharpe, once inside the Huletts Hotel, placed a candle next to a mattress soaked with kerosene. When the candle had burned long enough, the flame reached the mattress and caused the fire. Sharpe by that time was no longer in Huletts but was en route to Albany. (Courtesy of Lance DeMuro.)

This photograph shows the view out toward the present seventh fairway in 1915. The rock on the right would later house the expanded annex that would become the dormitory. (Courtesy of Kapusinski collection.)

Four

THE ARSON TRIAL AND THE SECOND HOTEL'S BIRTH

William H. Wyatt was a very smart man who also owned other hotels. The immediate problem he faced was that the fire completely ravaged the original structure. He had a very short time in which to rebuild before the next summer season would be upon him.

The problem he faced with the original hotel was its sanitation system. It had been constructed on an area that had grown swampy, and the sewage from the hotel was draining much too slow. The state was pressuring him to make improvements. He also wanted to improve the back of the hotel and move the barns and animals away. He needed to improve the grounds of any new hotel that he would construct. His customers were demanding it.

He had insured the original hotel, and that was the central part of the case the district attorney was bringing against him. He had to focus his energy on the trial. His son Arthur Wyatt was put in charge.

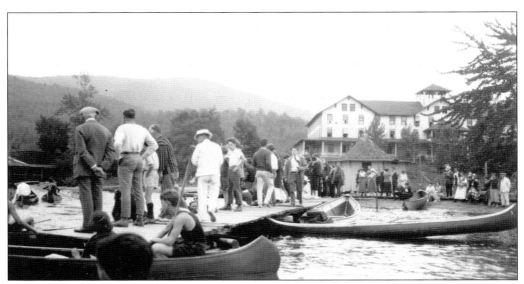

After the sensational fire of November 14, 1915, William H. Wyatt quickly rebuilt the Huletts Hotel for the 1916 summer season. Teams of workmen completed the new hotel by June 24, 1916. This picture is rare because it shows the newly constructed Huletts Hotel before the original waterfront casino was constructed. (Courtesy of Kapusinski collection.)

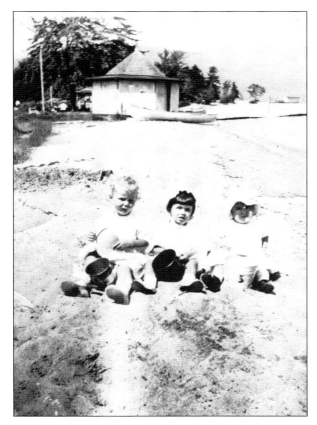

Children sit on the shoreline in the area where the original lakefront casino would be built. The gazebo behind them is where tourists would return their boats. (Courtesy of Kapusinski collection.)

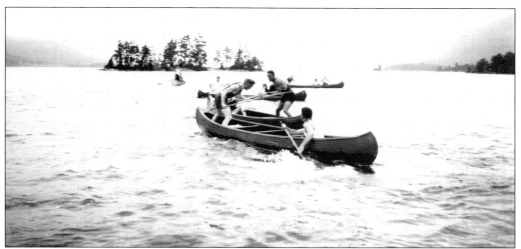

A "canoe war" was one of the activities that took place at the new hotel. Many daily activities were scheduled to keep the guests busy. One fact that is not well known is that Huletts fielded a baseball team. According to the *Lake George Mirror*, June 30, 1917, "The baseball team is being organized and they herewith challenge any team on the lake to play with them. The Huletts team has won many victories in the past years and they still hope to prove formidable opponents." (Courtesy of Kapusinski collection.)

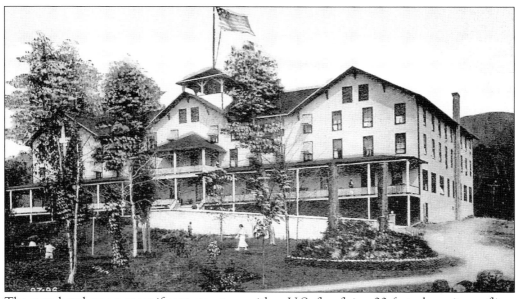

The new hotel was a magnificent structure with a U.S. flag flying 20 feet above its roofline. One of the best ways to date pictures of the second hotel is to see if the flagpole is present. It lasted for approximately 20 years until 1936, when it was either taken down or was blown off by a storm. It was not replaced and after 1936 is not seen in any later photographs. (Courtesy of Lance DeMuro.)

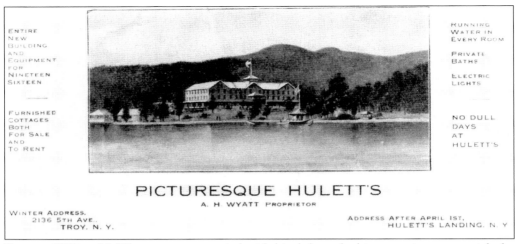

Because William H. Wyatt was preoccupied with his defense for his upcoming arson trial, the stationary for 1916 listed his son Arthur Wyatt as proprietor. "Entire New Building and Equipment for Nineteen Sixteen" as well as an artist's rendering of the new hotel were prominent. A new gazebo was also built on the shoreline. (Courtesy of Lance DeMuro.)

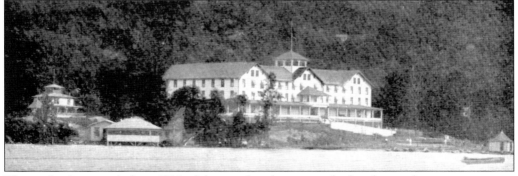

This early photograph from 1916 of the new hotel captures the boathouse that was present on the site where the new casino would be built a year later in 1917. The unique building on the left has not been identified. A tennis court can be seen clearly. (Courtesy of Lance DeMuro.)

This front-page newspaper article declares the end of the Wyatt case. Not guilty was the verdict on all counts. However, the case had taken a toll on William H. Wyatt. He died shortly thereafter, leaving the bulk of his estate to his wife and to his son Arthur Wyatt. (Courtesy of the *Fort Edward Advertiser*, May 24, 1917.)

Wyatt Case Closes.

"Not Guilty" was the verdict which a Washington county jury delivered to Judge Rogers at 5.20 o'clock Saturday afternoon in the Hudson Falls court house after about three hours deliberation on the evidence in the criminal action brought against William H. Wyatt, Northern New York hotel man, indicted in April on a charge of arson in the second degree.

The case attracted considerable attention and the court house was crowded throughout the trial. The favorable verdict was expected from the evidence. Attorneys on both sides delivered powerful addresses in summing up.

The new hotel was large and modern. Because it was built so quickly it did not have a foundation. Instead it was sited high, and the rock of the hill was used for support. From this vantage point, a system of gravity-fed sewage pipes made its waste disposal system one of the most effective in existence on the lake. (Courtesy of Kapusinski collection.)

The area where the first hotel stood was manicured into the lawn of the new hotel. Shortly after the fire there was no evidence whatsoever that the first hotel had ever occupied that spot. (Courtesy of Kapusinski collection.)

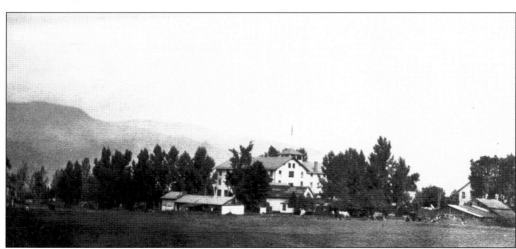

The landscape of Huletts was very different in 1917. Cows can be seen grazing in front of a barn that occupied part of what is now the third tee and fairway of the golf course. The bakeshop and linen room (which burned down in 1990) as well as the store are already present. However, the building that would become the present-day post office was not there at this time. (Courtesy of Kapusinski collection.)

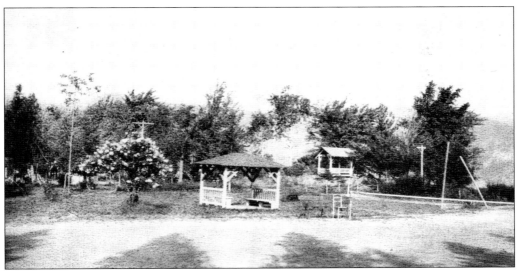

An early picture shows one of the tennis courts. It was only a clay surface, but the net is clearly there. A second gazebo is located closer to the lake. (Courtesy of Kapusinski collection.)

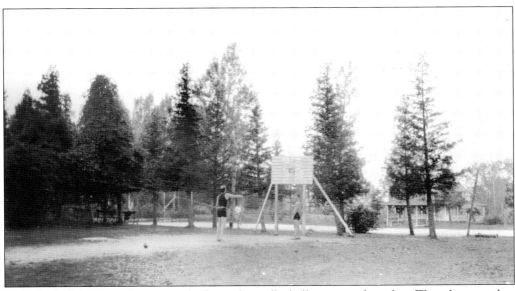

A basketball hoop and net stood where the volleyball net stands today. The photographer captured the basketball flying through the air on the right side of the first tree to the left of the hoop in 1917. (Courtesy of Kapusinski collection.)

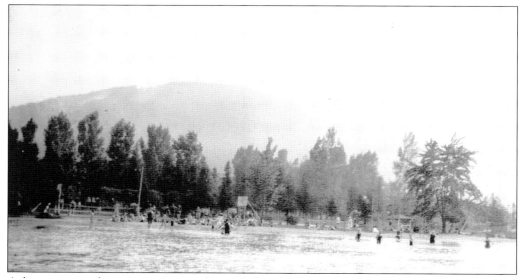

A large group of tourists swims in front of the tennis courts. Swimming would not become popular until the early part of the 20th century. Early travelers would sit on the lawn and view the lake in their finest clothes. From the size of the crowd, this must have been taken on a July or August day. (Courtesy of Kapusinski collection.)

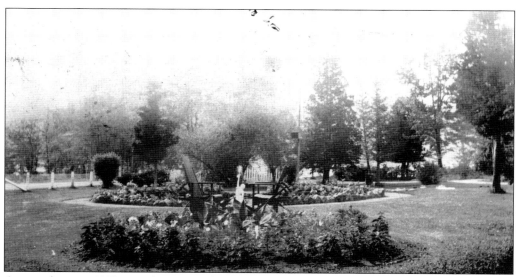

As seen here in 1917, two chairs were located at the new fountain, for lovers to gaze into each other's eyes. Arthur Wyatt catered to an upscale crowd and appealed to the affluent of the day. He did this by offering many activities and by creating an atmosphere where people could enjoy the natural surroundings. (Courtesy of Kapusinski collection.)

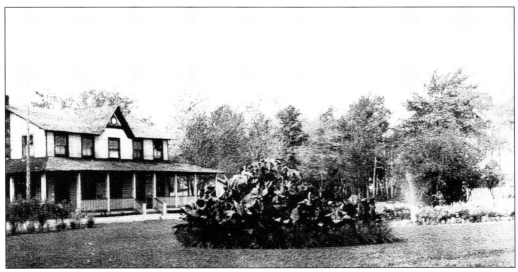

While DelNoce cottage was one exception, the road to the lake had few houses constructed along it yet. DelNoce was one of the original cottages constructed and predates almost every home in Huletts. (Courtesy of Kapusinski collection.)

New electricity poles in 1917 run to the cottages present at this time. As rural America received electricity, so did Huletts Landing. (Courtesy of Kapusinski collection.)

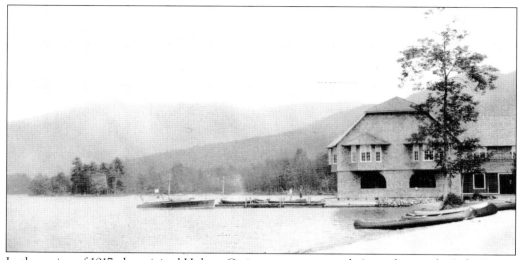

In the spring of 1917, the original Huletts Casino was constructed. According to the *Lake George Mirror*, June 30, 1917, "During the spring a new dancing casino has been constructed down on the lake shore side of the bowling alley. Here many of the smaller dances during the summer will be run off, the big ball room in the hotel being used for the larger dances." (Courtesy of Kapusinski collection.)

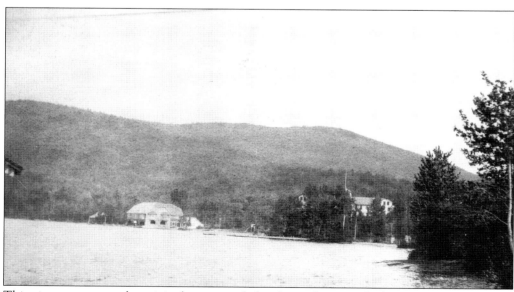

This picture captures the original casino and also shows the great dock constructed in front of the tennis courts. It extended some 200 feet from the rock in the center of the bay. It is unknown why it eventually disappeared. (Courtesy of Kapusinski collection.)

This photograph, taken from the long front porch of the Huletts Hotel in 1918, captures the side of the casino looking out toward Hulett's island. While there are many pictures of the front of the hotel, this picture, taken from the hotel porch looking out, is very rare. (Courtesy of Kapusinski collection.)

This photograph from 1918 shows the short front porch of the Huletts Hotel, looking back toward the golf course with the corner of the dormitory present. The dormitory was originally called "the annex" for overflow from the hotel but later was used exclusively to house hotel employees. (Courtesy of Kapusinski collection.)

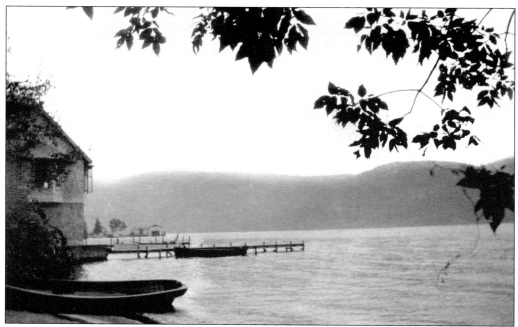

Few pictures exist of the original casino, so even this shot of an evening sunset with the casino at the left, from 1920, gives a unique perspective. Canoes and rowboats were available for the tourists to use. (Courtesy of Kapusinski collection.)

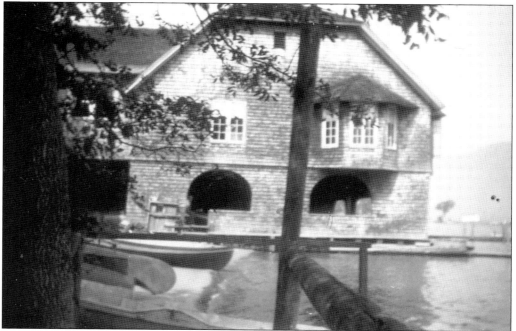

Part of the original casino was constructed over the water with room for boats underneath. One little-known fact about the casino is that the insurance agent for the company that insured it inspected the building two days before it burned down. (Courtesy of Kapusinski collection.)

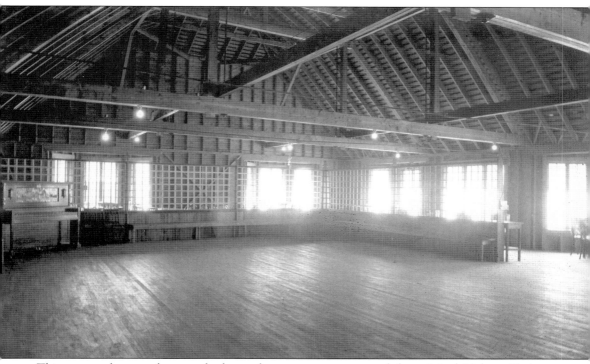

This extremely rare photograph shows the great upper room of the original Huletts Casino where live bands played in front of packed houses. It had wonderful views of the lake on three sides. (Courtesy of Kapusinski collection.)

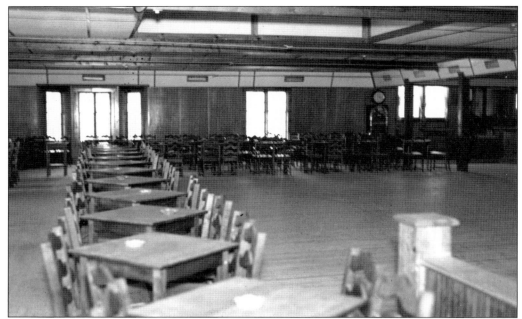

A night at the Huletts Casino during the 1920s cannot be easily described. While this picture shows part of the downstairs, the building was regularly packed on both floors. Music, dancing, and socializing overlooking the lake at night created an atmosphere that is not present anywhere today. (Courtesy of Kapusinski collection.)

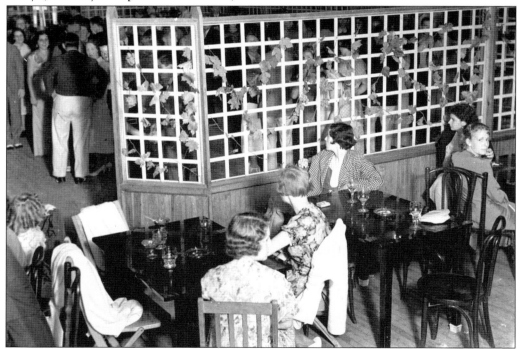

This picture of a weekend night in 1920 in the original Huletts Casino shows a typical crowd socializing and dancing in one of the downstairs rooms. (Courtesy of Kapusinski collection.)

Five

LIFE IN THE 1920S THROUGH 1940S

Life in the United States changed rapidly during these years. The Great Depression, World War II, the postwar economic boom, and the rise of the automobile all would have an effect in Huletts Landing.

The years would be marked by the Wyatts' ownership of the hotel and surrounding area, but by the end of the 1940s, change would come with Arthur Wyatt's death. Tourism remained the one strong constant throughout these years, and soldiers returning from different wars shared stories about their service overseas.

While Huletts was quiet, a lot was going on in the world. Some things never change.

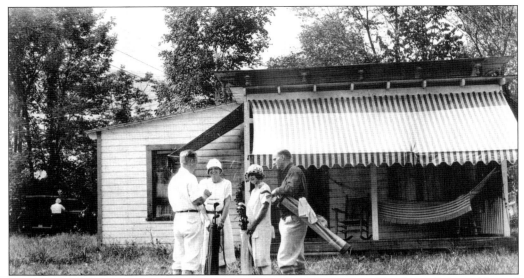

With the start of the Roaring Twenties, the clientele of the Huletts Hotel was fashionable and active. This picture shows golfers standing in front of the caddy house attired in their golfing finest. The length of grass that they played over was a bit higher than what would be expected today. The car to the left is a 1924 to 1926 Ford Model T sedan. (Courtesy of Kapusinski collection.)

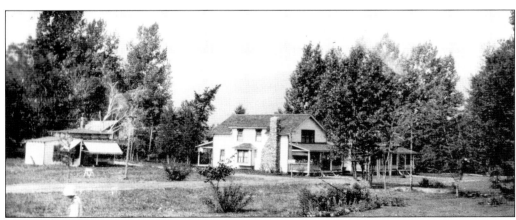

Some areas of the landing from the 1920s are clearly recognizable and very similar to present day. Huletts Landing was already exhibiting its charm and beauty, appealing to the affluent and sophisticated of the day. (Courtesy of Kapusinski collection.)

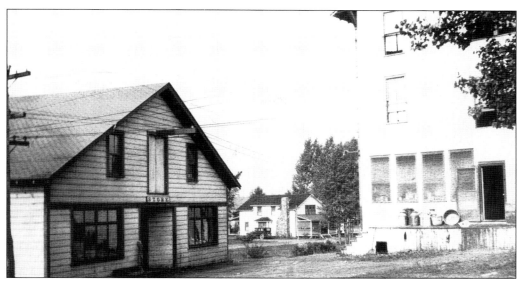

Milk was brought in cans to the back of the hotel directly from barns housing cows nearby. The store sold simple provisions and was equipped with an ice room. (Courtesy of Kapusinski collection.)

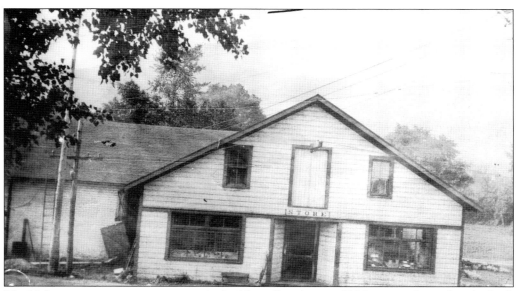

The Huletts store was never an attractive building. Seen here in 1926, it was relegated to the back of the property and when in service was described by a resident who remembered it as "functional and nothing more." Stores during this time were not the modern buildings one shops in today. It was over 80 years old when it was demolished in 2005. (Courtesy of Kapusinski collection.)

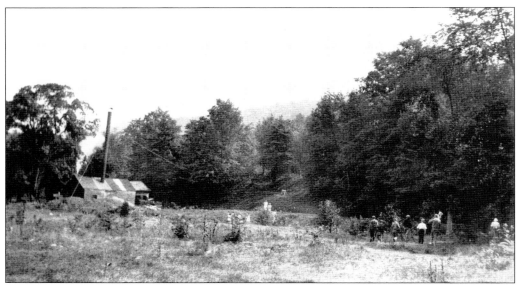

As golf became popular, tourists started playing on open areas of the property. This picture shows golfers playing on the fifth hole with the sixth high tee to the right in 1926. The building on the left with the high smokestack is the original sawmill. Today forest covers the site and is now the area below and to the right of the men's sixth tee. (Courtesy of Kapusinski collection.)

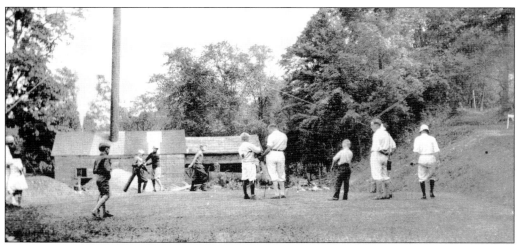

The original sawmill was located where the sixth out-of-bounds are today. Lumber was turned into boards that went into many of the structures in Huletts. Remnants of the foundation can be found today in the sixth fairway out-of-bounds overgrown by foliage. (Courtesy of Kapusinski collection.)

The first power lines into Huletts crossed over the mountain at the end of Bluff Head Road and were strung across the golf course to reach the hotel. This is why one of the rules on the back of the scorecard for the golf course states, "Ball striking wires may be replayed without penalty." (Courtesy of Kapusinski collection.)

The early golf course had more obstacles than those encountered today. These early golfers had to shoot around cows, barns, and spectators. (Courtesy of Kapusinski collection.)

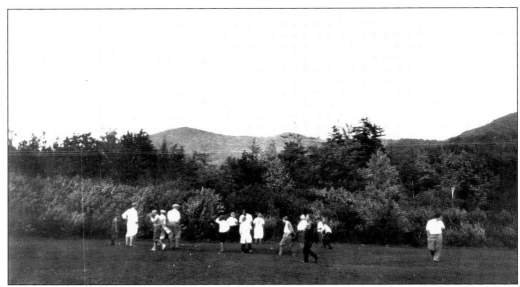

A large group in 1926 follows some golfers along what is now the eighth fairway. Golf during this time was becoming a pastime for the average person. As it caught on, many were learning the sport for the first time. (Courtesy of Kapusinski collection.)

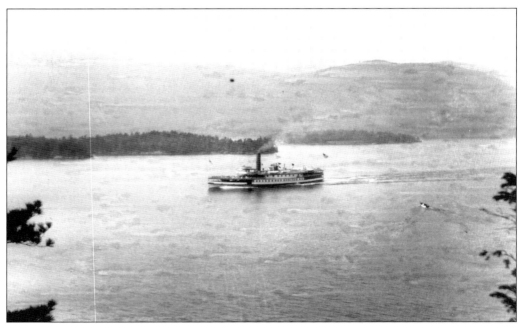

The SS *Horicon II* is seen in 1920 from Lands End with Vicars Island and the Paulist Father's Island in the background. The *Horicon II* was in service between 1911 and 1939. It was over 230 feet long and had a 59-foot beam. It was dismantled and sold for scrap in 1939. The chapel cannot be seen. (Courtesy of Kapusinski collection.)

The cottages at this time were simple structures. Here Villa Van, Elms, and Breakers can all be seen. The tree immediately to the left of the person sitting on the Elms step is the same tree that would be taken down in the 1990s after growing so large it had uprooted the front corner of the house. (Courtesy of Kapusinski collection.)

Guests sit on the porch of Richmond cottage in 1930. What is noticeable in all the early pictures of Huletts is the prominence of the American flag. Four U.S. flags can be seen hanging from the porch in this photograph. Times were lean in Huletts once the Depression started. (Courtesy of Kapusinski collection.)

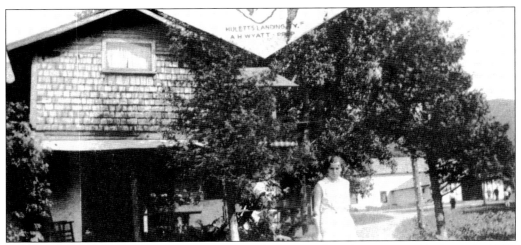

This view is looking past Lazy Day cottage toward what was then the garage and icehouse in 1930. As the automobile became more popular, a garage was constructed to house the automobiles of those who drove into Huletts. The entrance can be seen on the right. The large upstairs of the building was used to store ice year-round. (Courtesy of Kapusinski collection.)

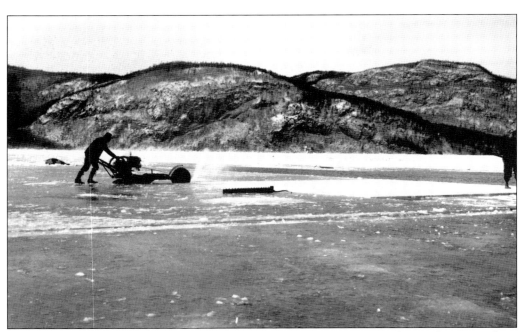

Ice would be cut out of the lake in the winter and stored year-round. This work, as seen here in 1934, was very dangerous. A workman could fall through the ice or be cut by the large blade on the saw. Yet ice was essential, and the lake provided it in abundance. (Courtesy of Kapusinski collection.)

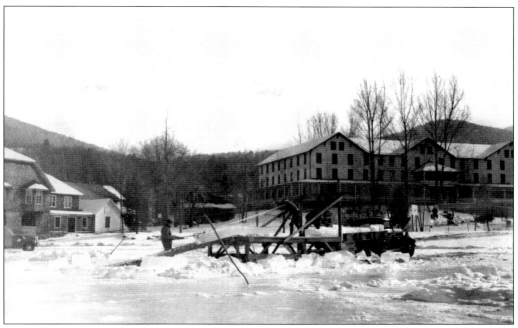

Blocks of ice, cut from the lake, would be loaded onto a truck. This picture was taken directly in front of the hotel. This work, done in the biting cold of winter, had to produce enough ice to last through the year. (Courtesy of Kapusinski collection.)

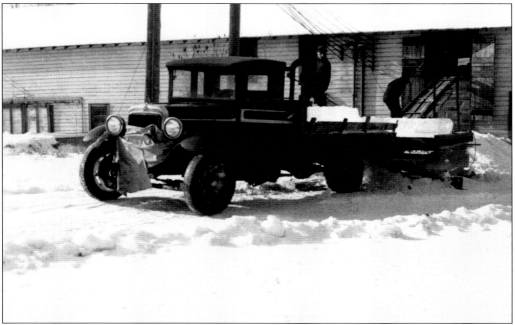

Frozen ice was unloaded and stored for the year in the icehouse. It was stored in large blocks and covered with sawdust to prevent it from melting. It would last through the year when packed this way. The truck seen here is a 1933 Ford. The icehouse would later be converted into the present-day casino after the original casino burned down in 1953. (Courtesy of Kapusinski collection.)

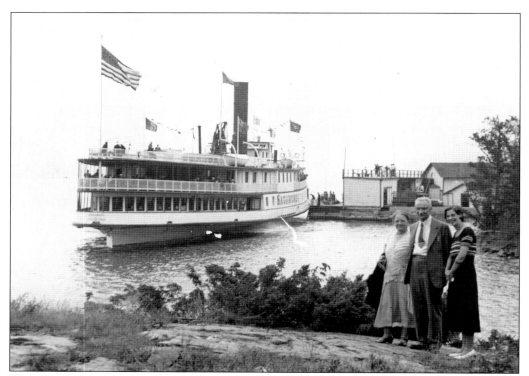

The ship *Sagamore* is docked at Huletts in 1934. One constant during these years was the daily arrival from the Lake George Steamship Company. The *Sagamore* was retired and dismantled in 1937. (Courtesy of Kapusinski collection.)

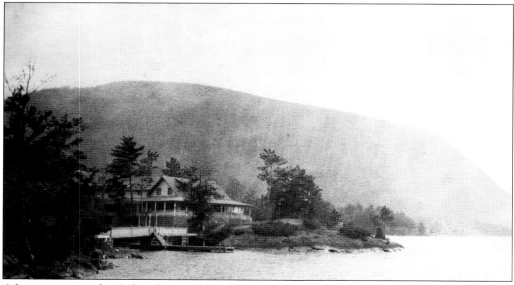

After acquiring the Lakeside Inn from Henry W. Buckell, Arthur Wyatt would go on to make it his personal residence. Elephant Mountain can be clearly seen in this photograph from 1935. The bridge between peninsulas has barely changed since the 1890s. (Courtesy of Kapusinski collection.)

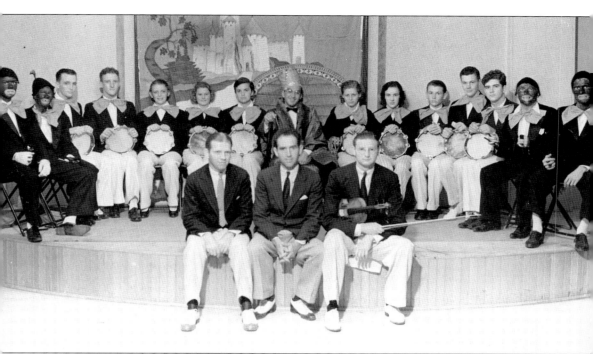

Performers are onstage at the Huletts Hotel. The orchestra leader, Moe Jaffe, was from Philadelphia and was quite talented. Seen here seated in the middle of the front row, he published a number of songs. Rita O'Neil, the aunt of current Huletts resident Lynn King, is seated in the back row, second to the right of the performer king. (Courtesy of Kapusinski collection.)

This view is looking in toward the Wyatt residence in 1935 from the front yard. One little-known fact is that Arthur Wyatt suffered a heart attack and died inside this residence on September 29, 1946. His death would trigger a series of events that would lead to the development of homes in Huletts Landing. (Courtesy of Kapusinski collection.)

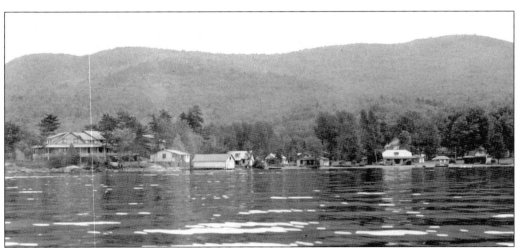

A view looking in toward the Wyatt residence in 1939 shows a different shoreline. The building next to the covered dock was a servants' quarters, and the shoreline did not have any stone riprap protection. During these years, almost 20 feet of frontage was lost to erosion. (Courtesy of Kapusinski collection.)

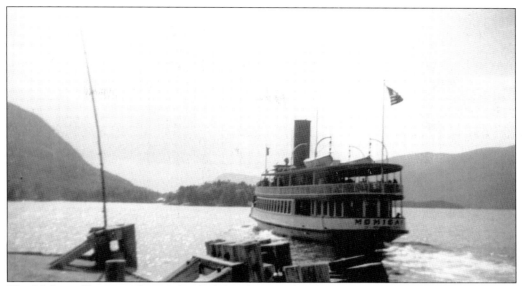

The *Mohican II* steamer leaves the dock heading south. The *Mohican II* was in service between 1908 and 1946. Its distinctive smokestack and lifeboats stored on the top deck can be clearly seen. (Courtesy of Kapusinski collection.)

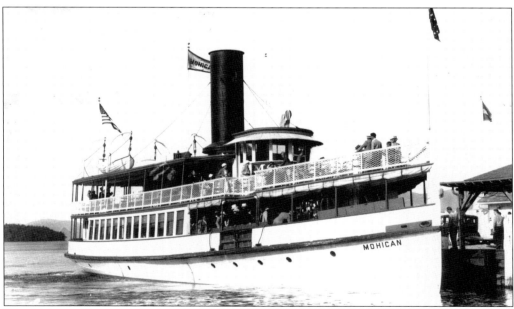

The *Mohican II* is named after the Mahican Indians who lived in the Hudson River Valley. Although similar in name, the Mahicans were not Mohegans, a different Algonquian-speaking tribe living in eastern Connecticut. James Fenimore Cooper's novel *The Last of the Mohicans* is based on the Mahican tribe but includes some cultural aspects of the Mohegans. The novel takes place on Mahican land, but some characters' names, such as Uncas, are Mohegan. (Courtesy of Kapusinski collection.)

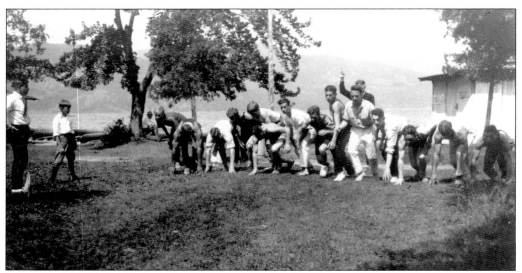

Soldiers returning from World War II recounted their stories while vacationing. Seen here in a footrace, many of the young men arriving in Huletts had seen combat in Europe or the Pacific. Longtime guest Reginald Ballantyne received two Purple Hearts fighting in the mountains of Italy. "I was lucky to get back," he recounted years later, "a lot of fellows I served with didn't." (Courtesy of Kapusinski collection.)

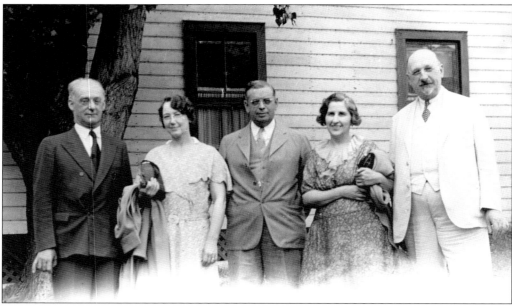

After Arthur Wyatt's death in 1946, his estate would sell the property to the Huletts Landing Corporation. Shown in the center of this photograph, Arthur Wyatt had gone on to serve as Dresden town supervisor. He was known as a very good businessman who had worked the greater part of his life to improve Huletts Landing. (Courtesy of Kapusinski collection.)

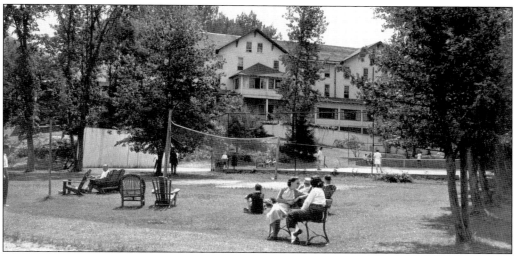

The hotel began to show its age. By 1947, the hotel was 30 years old and needed an infusion of capital for much-needed improvements. The Huletts Landing Corporation did not succeed financially and sold the property in January 1953 to George and Margaret Eichler. (Courtesy of Kapusinski collection.)

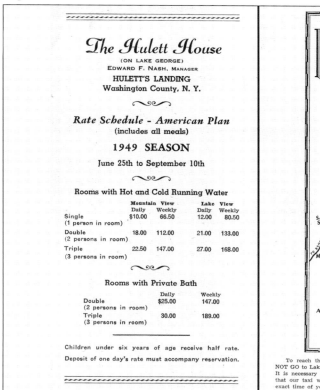

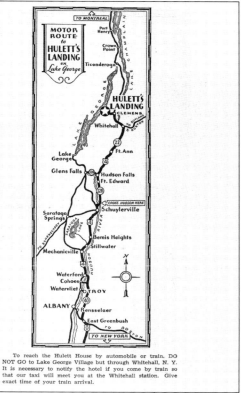

This rate card is from 1949 for the hotel, with an automobile map on the back. Route 4 predated Interstate Route 87 and was the preferred road from Albany. (Courtesy of Kapusinski collection.)

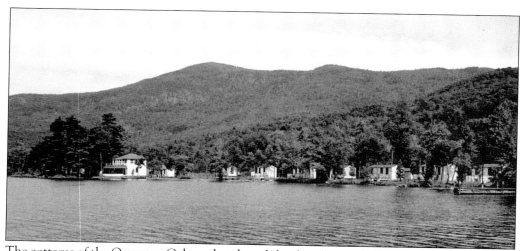

The cottages of the Owenoco Colony that dotted the shoreline in 1949 were much smaller than what exists today. The building that houses the present-day Huletts Island View Marina was a store and eating establishment operated by Herman Benjamin. (Courtesy of Kapusinski collection.)

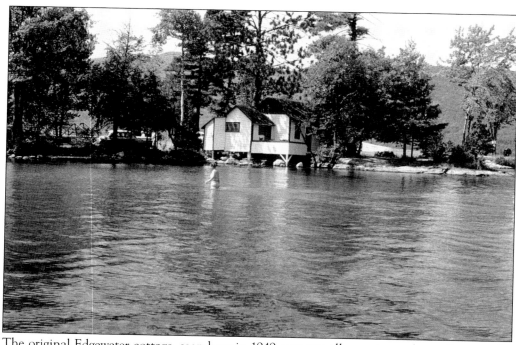

The original Edgewater cottage, seen here in 1949, was actually constructed on stilts over the water. As time passed, many owners added onto their relatively small seasonal homes. (Courtesy of Kapusinski collection.)

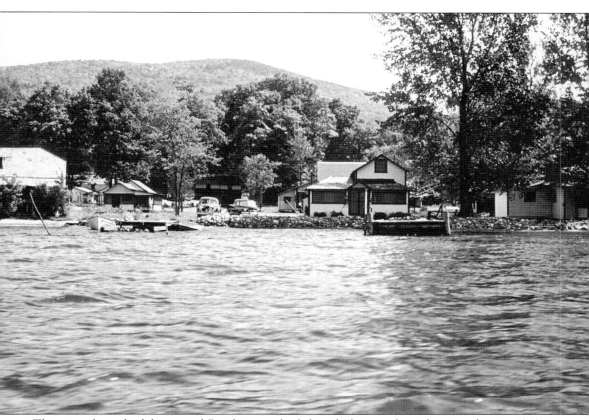

This view from the lake toward Breakers on the left and Elms on the right was taken in 1949. When booking a stay at Huletts Landing, guests could also rent cottages. One of the problems that the Huletts Landing Corporation ran into was that some shareholders wanted to spend corporate money on improving the houses they stayed in. This caused resentment between shareholders. (Courtesy of Kapusinski collection.)

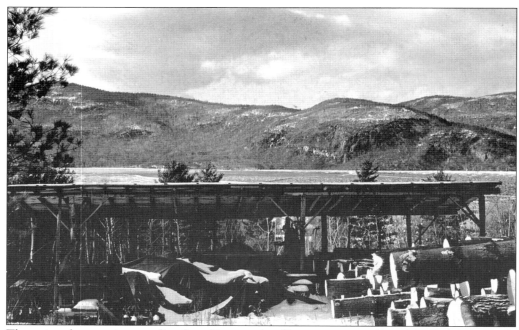

The unique knotty pine paneling found in many local homes was a product of the Huletts sawmill. Located first next to the sixth fairway out-of-bounds, it was later located on the south side of County Route 6 as the road comes down the mountain. (Courtesy of Kapusinski collection.)

Six

THE END OF THE HOTEL AND THE START OF HOME OWNERSHIP

George and Margaret Eichler and their daughter, Margaret, nicknamed Margot, originally came to Huletts as guests in 1946. They wanted to go somewhere far enough away from their home in New Jersey that they could get a complete vacation.

George Eichler was a true American success story. He sailed around the world for the Barber steamship lines at age 19 in 1919, thus becoming one of the few people of his generation to see the Pacific Rim countries before World War II. He went on to own and publish a number of trade magazines for the petroleum industry. He was an enthusiastic aviator who held a private pilot's license and traveled over one million miles on commercial airlines, something uncommon in that day.

He was one of the original shareholders in the Huletts Landing Corporation, which purchased the property from the Wyatt estate. When the corporation failed, he was the only shareholder to make an offer on the property.

George Eichler strongly believed that a vacation and homeownership should be affordable to the average family. He made every attempt to see that children were welcome in Huletts, understanding the unique characteristics of the property he had purchased.

His foresight and charisma would change Huletts forever.

THE **NEW OWNERS** OF
PICTURESQUE HULETT'S on **LAKE GEORGE**

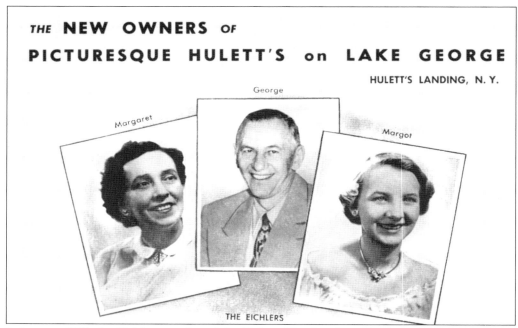

THE EICHLERS

In January 1953, the Eichlers purchased the Huletts Hotel and surrounding property. As former guests and shareholders in the Huletts Landing Corporation, the Eichlers had a clear vision of what they wanted to accomplish in Huletts. They brought immediate vitality and energy to the area. (Courtesy of Kapusinski collection.)

This view of the former Lakeside Inn/Wyatt residence was taken in 1953. Mary Wyatt, Arthur Wyatt's wife, would continue to live in the former Lakeside Inn, which had become the Wyatt residence, until her death in 1967. Arthur Wyatt's estate stipulated in the sale to the Huletts Landing Corporation that Mary Wyatt be allowed to live in the residence until the end of her natural life. (Courtesy of Kapusinski collection.)

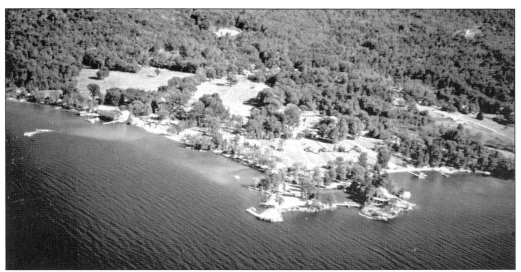

One of the earliest aerial views of Huletts Landing was taken in 1953. The original casino and the hotel are present. The present-day casino has an entrance in front for inside automobile parking. Numerous houses and cottages are not yet present. (Courtesy of Kapusinski collection.)

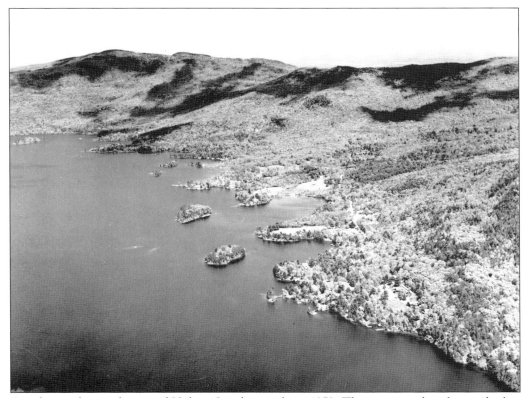

Another early aerial view of Huletts Landing is from 1953. This picture, shot from a higher altitude, shows less overall development than exists today. (Courtesy of Kapusinski collection.)

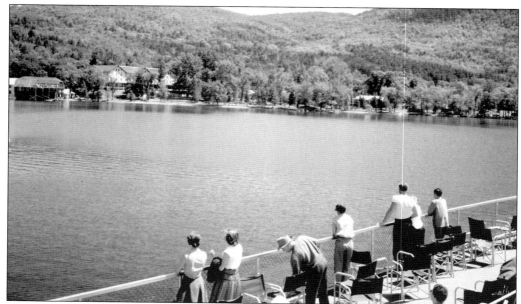

Passengers look in toward Huletts in 1953, with the original casino's roof being replaced. The Eichlers made immediate improvements to the casino during their first year of ownership, adding a soda fountain and replacing the roof, which at that time was over 35 years old. This photograph, taken from the deck of the *Ticonderoga*, was shot literally days before the casino burned down and clearly shows the roof being replaced. (Courtesy of Kapusinski collection.)

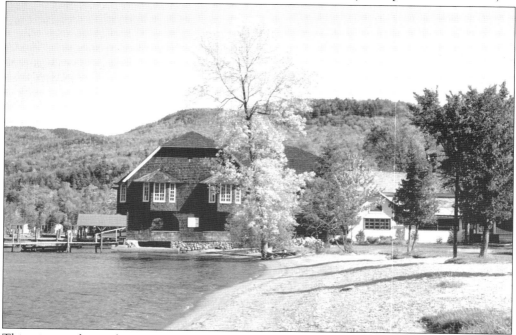

This picture shows the size and location of the original casino and how close it was to the beach. Music and dancing were a regular occurrence until approximately 2:00 a.m. (Courtesy of Kapusinski collection.)

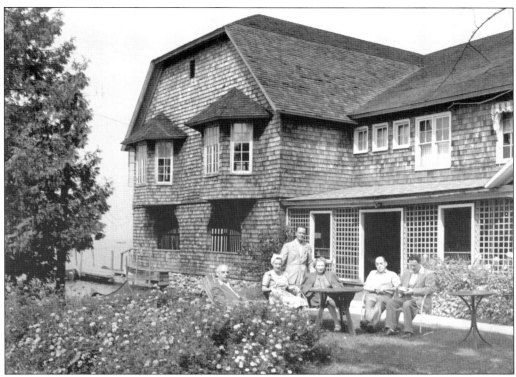

The casino's flower garden was located right in the middle of the adjoining beach area. The picture below was taken shortly before the fire of 1953 and shows some substantive changes since 1943. The picture above was taken 10 years earlier. One of the changes the Eichlers made was to have the steps open out onto the beach area. (Courtesy of Kapusinski collection.)

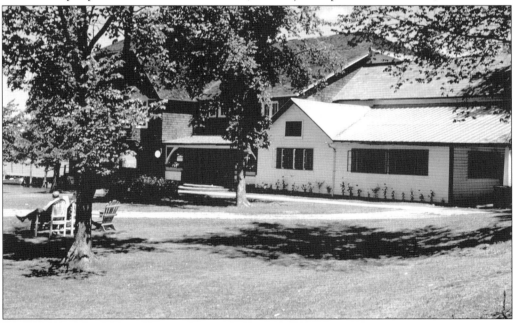

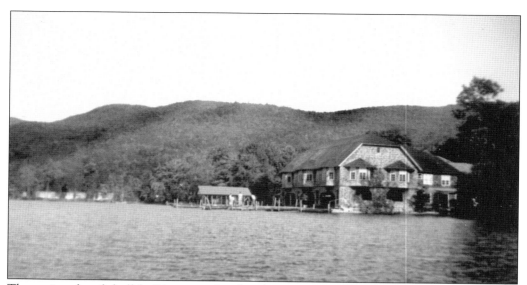

The casino dwarfed all buildings on the shoreline and was the central point of the landing. Advertisements of the day refer to dancing, concerts, and bands that played there. The famous woman aviator Amelia Earhart came to the casino as a young woman when her family stayed in Huletts. (Courtesy of Kapusinski collection.)

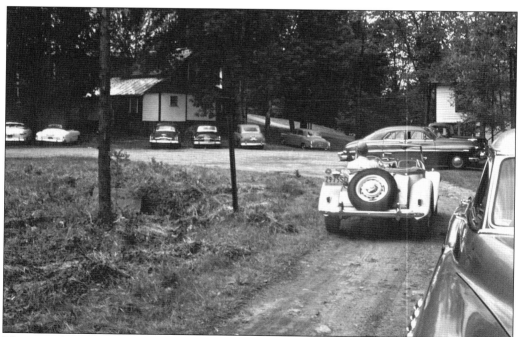

This rare photograph shows the road behind the original casino in 1953. The back of the casino can be seen at the far right. The cars in this photograph would be considered classic automobiles today. (Courtesy of Kapusinski collection.)

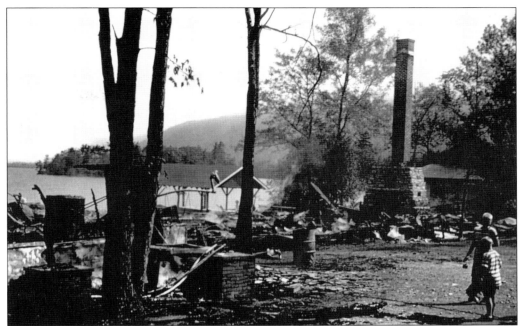

The fire that destroyed the original casino started at about 2:00 a.m. in the summer of 1953. The major fear that evening was that it would spread to the hotel. Fortunately, it did not. The most likely cause of the fire was a cigarette discarded in a wastebasket. This picture shows the complete destruction of the building. (Courtesy of Kapusinski collection.)

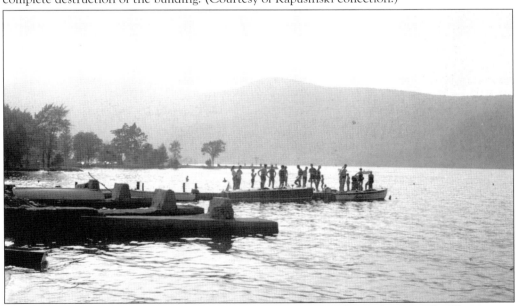

The Eichlers suffered a devastating loss when the casino caught on fire in 1953. This picture shows the destruction of the docks in front. Because of what happened in 1915 with the first hotel, a full investigation was undertaken and there was never any hint or suspicion that arson was involved. Both George and Margaret Eichler considered this one of their darkest hours in Huletts. (Courtesy of Kapusinski collection.)

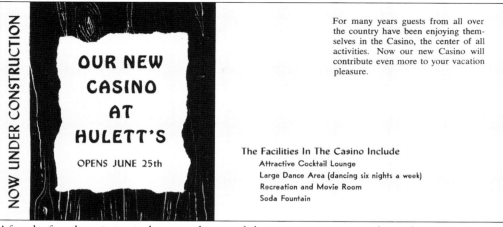

NOW UNDER CONSTRUCTION

OUR NEW CASINO AT HULETT'S

OPENS JUNE 25th

For many years guests from all over the country have been enjoying themselves in the Casino, the center of all activities. Now our new Casino will contribute even more to your vacation pleasure.

The Facilities In The Casino Include
Attractive Cocktail Lounge
Large Dance Area (dancing six nights a week)
Recreation and Movie Room
Soda Fountain

After the fire, the existing icehouse and automobile garage were converted into the existing casino. This brochure notified tourists that it would open in the summer of 1954 and showed an artist's rendering of what the proposed building would look like. (Courtesy of Kapusinski collection.)

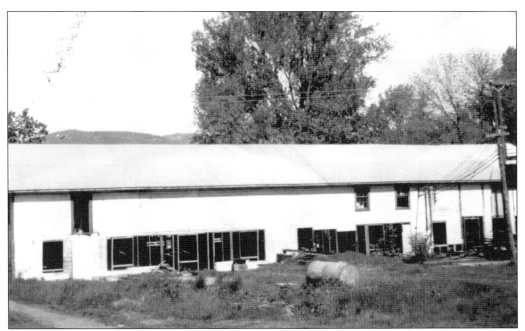

Renovation of the icehouse and garage took place through the fall and winter of 1953 and 1954. This picture shows windows being placed in the back of the building. (Courtesy of Kapusinski collection.)

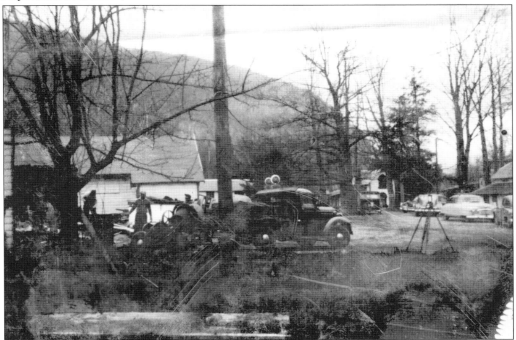

Workmen are in front of the existing casino as it is being renovated in 1954. The oak tree in the front of Garden View cottage can be seen. It is estimated that this tree is between 150 and 250 years old. (Courtesy of Kapusinski collection.)

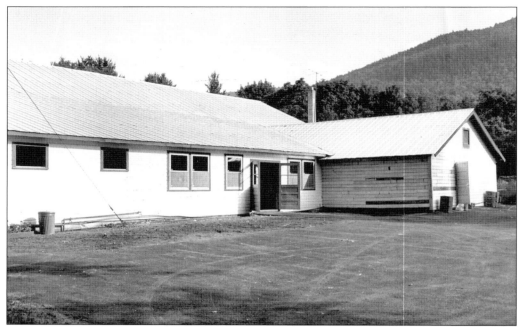

The renovation of the casino was not yet complete in 1954 when this photograph was taken. While work was almost over, some finishing touches remained. No windows were yet present in the office. (Courtesy of Kapusinski collection.)

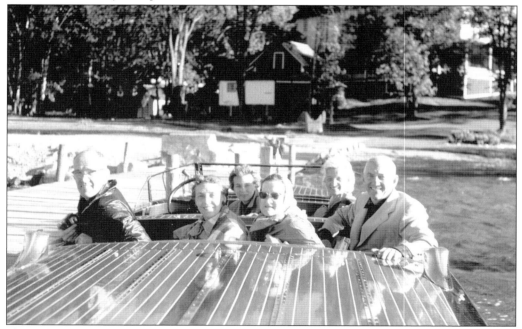

Shown here sitting in a boat in front of the hotel and the old Idle Hour cottage, after the casino burned down, the Eichlers would ultimately take down the hotel. George Eichler is on the right with his daughter, Margot, behind him. Margaret Eichler is second from the left. (Courtesy of Kapusinski collection.)

Hulett's Golf Club

Hulett's Landing, N. Y.

SCORE CARD

**All Players Must Register
Before Play**

No.	Yds.	Par	Strokes			
1	275	5	1			
2	160	3	13			
3	170	4	11			
4	120	3	17			
5	100	3	15			
6	185	4	9			
7	210	4	5			
8	245	4	3			
9	165	4	7			
Out	1630	34				

Player _____

Attested _____

Date _____

The golf scorecard from the mid-1950s indicates that the first hole of the golf course was once a par five. Early scorecards from the golf course, especially unused ones, are extremely rare. (Courtesy of Kapusinski collection.)

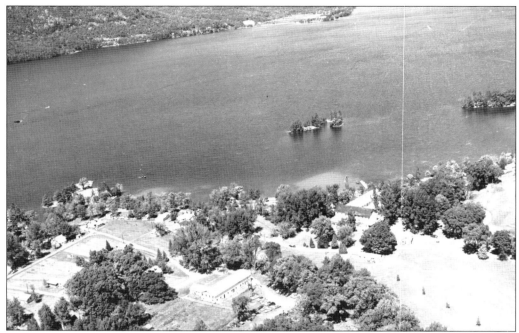

An early aerial photograph from 1955 shows Huletts as its growth progressed. There are hardly any houses in the center section of Huletts, and the trees between the first and second fairways of the golf course are much smaller. (Courtesy of Kapusinski collection.)

DelNoce cottage has a long and storied history. The Eichlers used this as their winter home throughout the 1960s. Seen here with its furnace room in the back, DelNoce has been housing guests since the late 1800s. (Courtesy of Kapusinski collection.)

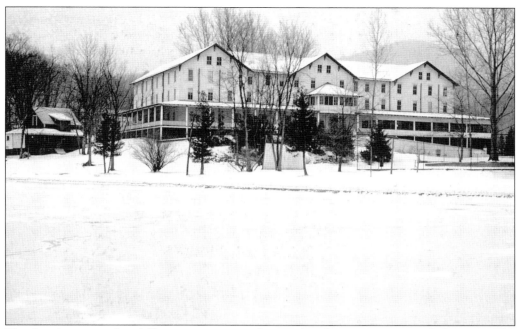

The hotel presented a different appearance during the changing seasons of the year. The hotel was not heated and was closed during the winter. The picture above shows the hotel as it appeared in the middle of winter. The picture below shows the full seasonal foliage in front. (Courtesy of Kapusinski collection.)

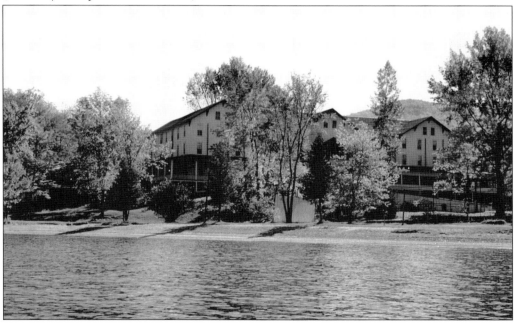

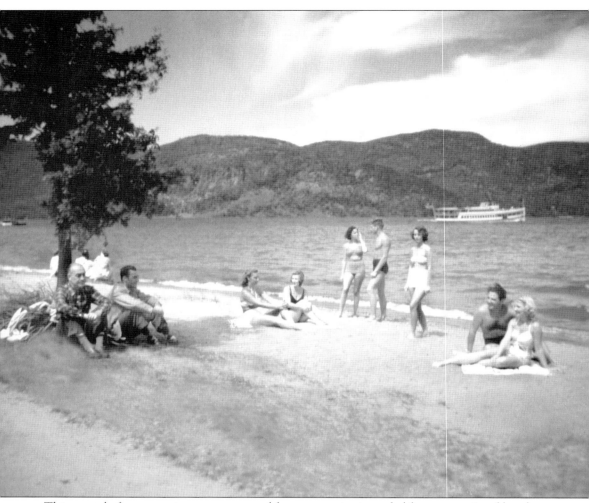

This never-before-seen picture was restored from a negative intended for a promotional brochure. It was badly damaged but is presented here due to advances in photographic restoration. The ship in the background is the diesel-powered *Mohican*, in service between 1947 and 1966. (Courtesy of Kapusinski collection.)

One constant on the grounds of the hotel was the fountain. Seen above looking out toward the lake, and seen below facing toward the tennis courts, the fountain actually contributed to the drainage of the lawn. Groundwater was collected and fed into the pool. (Courtesy of Kapusinski collection.)

Most activities on the landing were centered around the hotel. This picture taken in 1955 from the grounds of the hotel toward the steamship dock shows how minimally developed Huletts was at this time. (Courtesy of Kapusinski collection.)

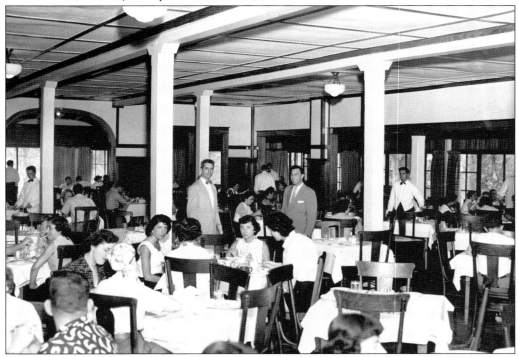

Guests are seen dining in the hotel's main dining room in 1955. The food and the service were both excellent. (Courtesy of Kapusinski collection.)

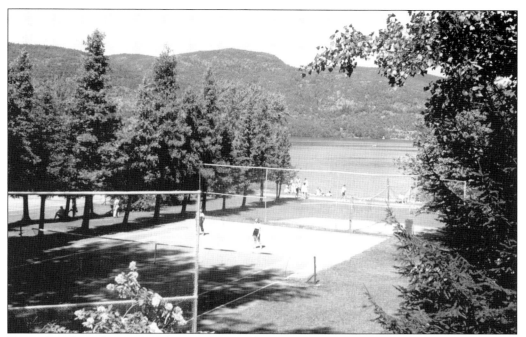

Tennis has always been a popular activity at Huletts. Seen here in the mid-1950s, the tennis courts have changed little since they were originally installed. (Courtesy of Kapusinski collection.)

The decision to take down the hotel was made for a number of reasons. After the casino fire of 1953, modern fire alarms and escapes were installed in the hotel. However, it was constructed entirely of wood and would have burned down quickly if it had caught fire. Many of the large hotels in the Adirondacks were destroyed by fire. (Courtesy of Kapusinski collection.)

Rising assessments caused the property taxes to increase exponentially. One little-known fact is that the Eichlers won a tax assessment case against the town, resulting in the public resignation of the town assessor. Even with this victory, rising taxes made doing business almost impossible. (Courtesy of Kapusinski collection.)

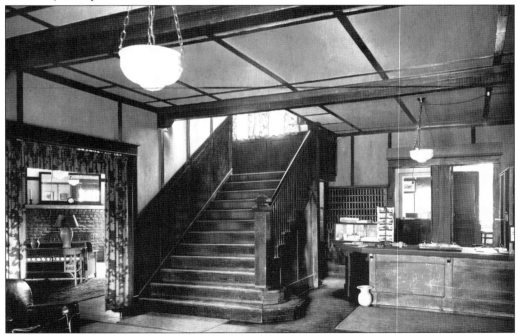

This view is inside the main lobby of the hotel facing the front desk. This is the spot where guests checked in and out for over 40 years. A postcard stand can be seen on top of the front desk. (Courtesy of Kapusinski collection.)

This is the living area in a two-room apartment in the hotel. These accommodations were actually quite modern for the 1950s. The plant on the table on the left was drawn in by a graphic artist for a promotional brochure. (Courtesy of Kapusinski collection.)

Here is a double-occupancy room in the hotel. George Eichler was so concerned about a fire in the hotel that the hallways were checked multiple times during the day and night for any signs of smoke or fire. This was done even after the new fire alarm system was installed. (Courtesy of Kapusinski collection.)

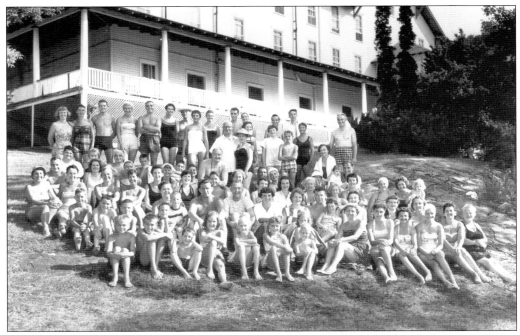

Many group photographs were taken of guests who stayed in the hotel during 1959, its last year in operation. Some of the people in these pictures are still living. (Courtesy of Kapusinski collection.)

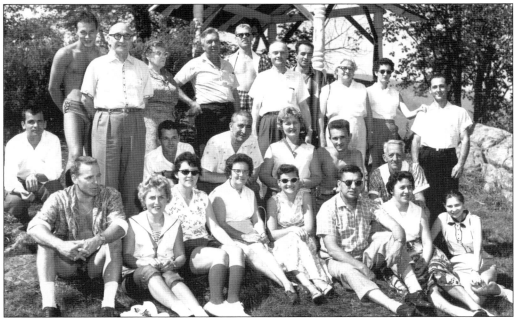

The last guests at the hotel represented a cross-section of America in 1959. This picture, taken in front of the former gazebo on the rock past the lower tennis court, captures a group of New Jersey tourists before they left to go home. Sadly, this would be their last stay at the hotel. (Courtesy of Kapusinski collection.)

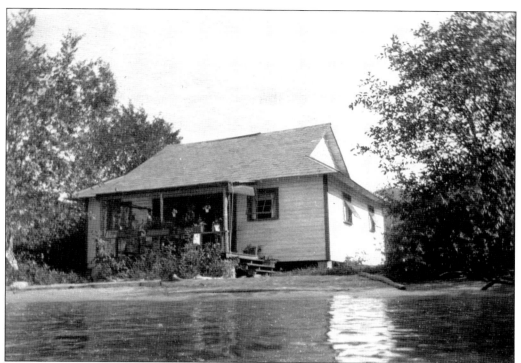

Lakeside cottage was always located next to the original casino. The original Lakeside cottage was moved from its original location (shown in the photograph above about 1920) to its new location (the house on the left behind the trees in the picture below) when the new Lakeside cottage was constructed in 1959. The house in front of the hotel is the old Idle Hour cottage. (Courtesy of Kapusinski collection.)

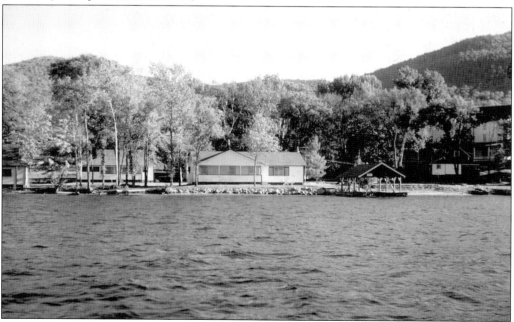

ACTIVITIES SCHEDULED FOR WEEK OF JULY 25-AUG. 1
HULETT'S ON LAKE GEORGE

SATURDAY, JULY 25:
5:00 P.M. GET-ACQUAINTED COCKTAIL HOUR — CASINO BAR
9:30 P.M. " " DANCE — CASINO

NOTE: 'TALENT' REPORT TO SOCIAL HOSTESS, FLO McGOWAN
FOR SUNDAY AND THURSDAY SHOWS

SUNDAY, JULY 26:
9:00 P.M. VARIETY SHOW — HOTEL BALLROOM
10:00 P.M. DANCING — CASINO

MONDAY, JULY 27:
9:30 A.M. SIGN UP FOR TENNIS TOURNAMENT
9:45 A.M. FREE TENNIS INSTRUCTION
10:30 A.M. DANCE INSTRUCTION IN CASINO
12:20 P.M. BOAT TRIP TO BALDWIN — SEE HOSTESS
3:00 P.M. SOFTBALL GAME — STAFF vs GUESTS
8:15 P.M. GAMES & QUIZ — BALLROOM
9:30 P.M. SWITCH DANCE (SOME SQUARE DANCES)

TUESDAY, JULY 28:
10:15 A.M. 3-MILE HIKE TO LAND'S END
3:00 P.M. WATER MEET
7:45 P.M. PING PONG TOURNAMENT
9:00 P.M. MOVIE "MOTHER IS A FRESHMAN" — CASINO

WEDNESDAY, JULY 29:
10:15 A.M. SOFTBALL GAME — MEN AND WOMEN
1:45 P.M. SCOTCH FOURSOME GOLF TOURNAMENT
8:00 P.M. CARD PARTY — BALLROOM (SIGN UP ON PORCH)
9:30 P.M. SONG TITLE DANCE (PRIZES) — CASINO

THURSDAY, JULY 30:
10:15 A.M. TENNIS EXHIBITION
11:30 A.M. BOAT TRIP TO LAKE GEORGE VILLAGE — SEE HOSTESS
2:00 P.M. TENNIS INSTRUCTION
3:00 P.M. VOLLEYBALL GAME
9:30 P.M. AMATEUR SHOW AND DANCE— CASINO

FRIDAY, JULY 31:
10:30 A.M. SOFTBALL GAME
2:00 P.M. HOLE-IN-ONE GOLF CONTEST
3:30 P.M. MEN'S "BATHING BEAUTY" CONTEST — SIGN UP
9:30 P.M. FAREWELL DANCE — CASINO

SWIMMING LESSONS $1.25 EACH
SEE JIM GILHOOLEY, INSTRUCTOR

This activity sheet from 1959, the last year the hotel was open, shows weekly activities that guests could participate in. There was always something for everyone. (Courtesy of Kapusinski collection.)

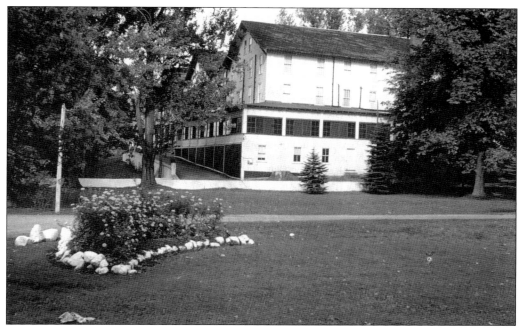

The land side corner of the hotel was the side people walked to as they arrived by car. By the late 1950s, the majority of people staying in Huletts were arriving by car. (Courtesy of Kapusinski collection.)

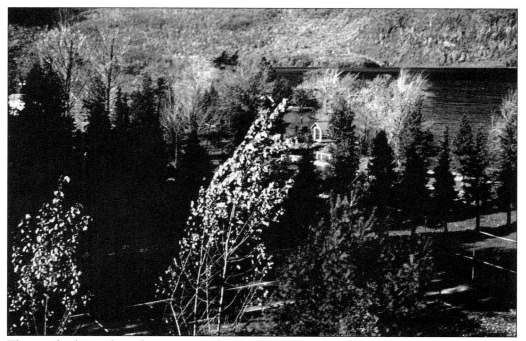

This is a final view from the top room of the hotel. The room on the top floor at the center of the hotel offered a spectacular view west. This is one of the final pictures taken from that room. It captures the view a guest staying in that room would see. (Courtesy of Kapusinski collection.)

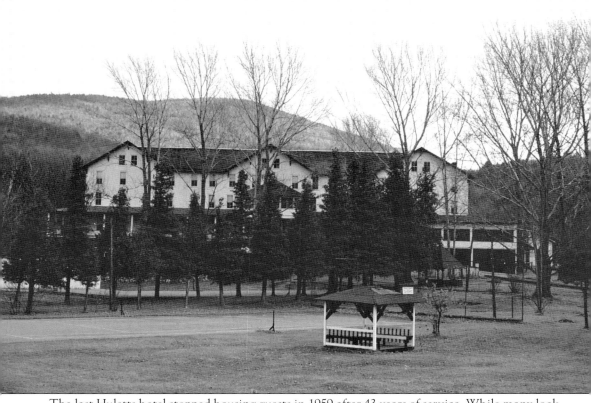

The last Huletts hotel stopped housing guests in 1959 after 43 years of service. While many look back nostalgically, the time of the great hotel was ending throughout the Adirondacks and a new era was beginning. (Courtesy of Kapusinski collection.)

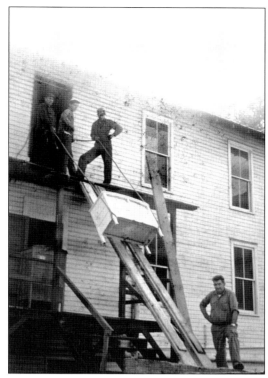

The first step in demolishing the hotel was to completely empty it. Workers can be seen here emptying the contents of different rooms. This was a painstakingly slow process, especially for furniture on the upper floors. (Courtesy of Kapusinski collection)

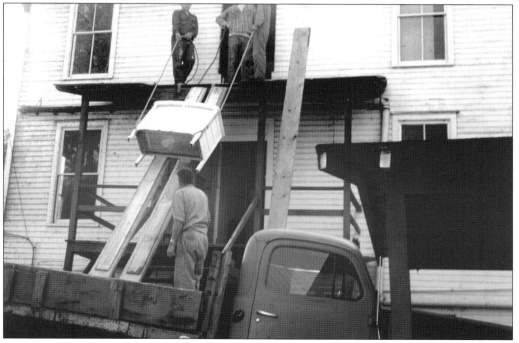

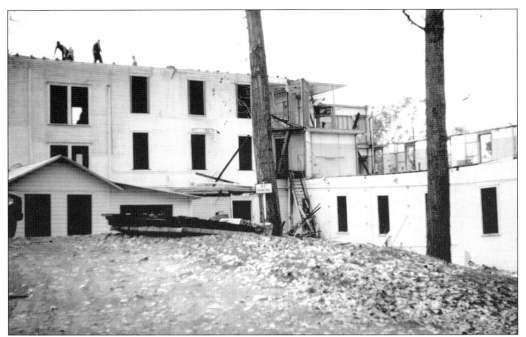

After the building was emptied, demolition began. The roof was taken off first, and then the upper floors were demolished. The entire process took only about eight weeks. (Courtesy of Kapusinski collection.)

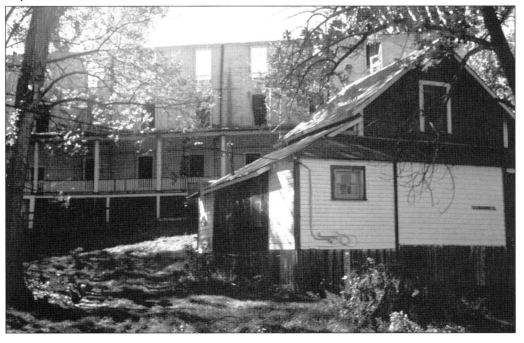

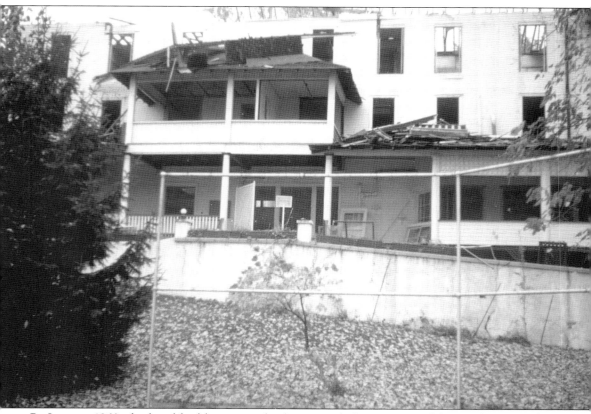

By January 1960, the hotel had been completely removed. Construction debris and any wood that could not be salvaged were burned on the spot. (Courtesy of Kapusinski collection.)

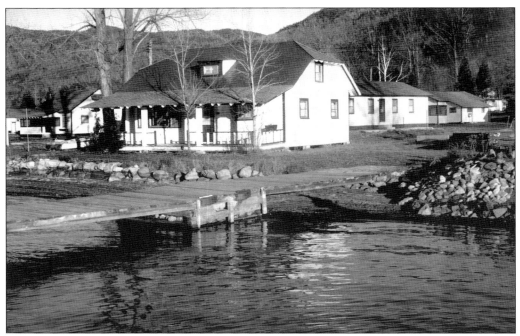

The wood from the hotel went into the development of houses, and the community expanded. The Eichlers were firm believers that a vacation or a second home should be available to the average family and not just the wealthy. (Courtesy of Kapusinski collection.)

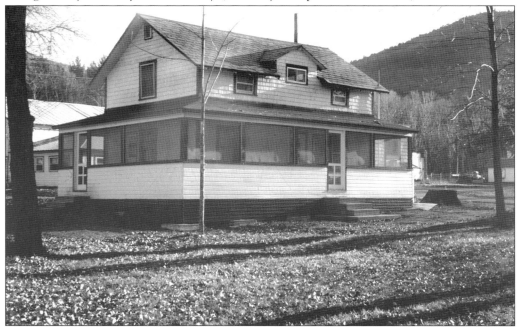

The 1960s was a decade of growth in Huletts. The gravel pit was enlarged as fill was needed to construct new houses. Many longtime renters became homeowners. (Courtesy of Kapusinski collection.)

As new houses were constructed, the landscape changed. Some changes, like the one seen above, were minimal. Other changes were quite radical, as even streams were diverted. (Courtesy of Kapusinski collection.)

The development of houses continued throughout the 1960s. In an effort to allow families to own their own homes, the Eichlers held mortgages from many of the families they sold to. In doing so, they helped the buyers create happy memories from owning a second home and wealth, as these houses quickly appreciated in value. (Courtesy of Kapusinski collection.)

Wood from the hotel also went into a variety of other structures. A recreation room was built next to the casino for children's activities. (Courtesy of Kapusinski collection.)

The view out toward Burgess Island was almost unchanged 100 years after the first picture of Huletts Landing was taken in 1869. While Huletts has grown during the last century, its charm and beauty remain. (Courtesy of Kapusinski collection.)

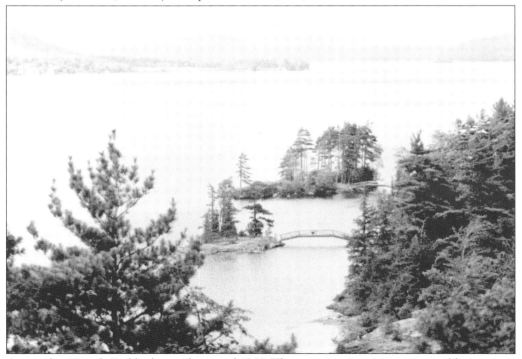

A view from Lands End looks north around 1960. The area grew in ways unimaginable just years before. (Courtesy of Kapusinski collection.)

It was once possible to buy gasoline at multiple places in Huletts Landing. Gasoline for boats was sold at the dock next to Lakeside cottage, and gasoline for cars was available next to the present-day casino. Today the choices are much more limited. (Courtesy of Kapusinski collection.)

FIVE FAMILIES AT HULETTS LANDING HAVE 39 CHILDREN

tured, left to right, with their families are: Mr. and Mrs. Gerard O'Brien of Garden City, Mr. a
s. Luke Smith of Merrick, L. I., Mr. and Mrs. Reginald Ballantyne of Westbury, L. I., Mr. and M
eph Boland of Hartsdale, N. Y., and Dr. and Mrs. Paul Hurley of Jamaica Plain, Mass., all of wh
e been enjoying the month of August on Lake George.

Families remained the primary clientele. Large families abounded in the 1960s. Five families
with a total of 39 children were photographed in 1961. (Courtesy of Kapusinski collection.)

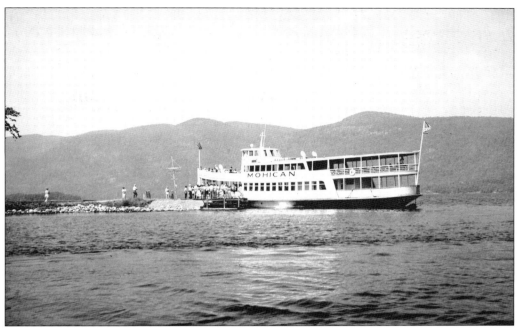

During this period, different boats of the Lake George Steamship Company continued to dock at Huletts Landing. Seen here in 1962, the *Mohican*, while one of the smaller boats in the fleet, still could not completely fit at the dock. (Courtesy of Kapusinski collection.)

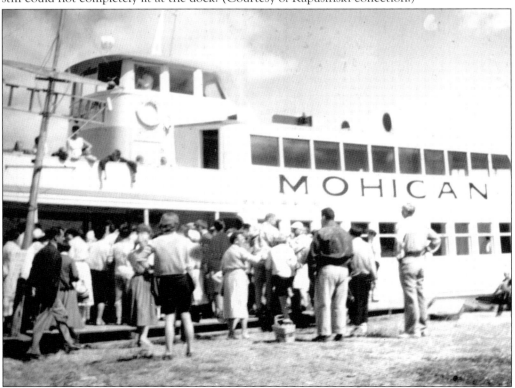

PRESIDENT KENNEDY'S COUSIN VACATIONS AGAIN AT HULETTS ON LAKE GEORGE

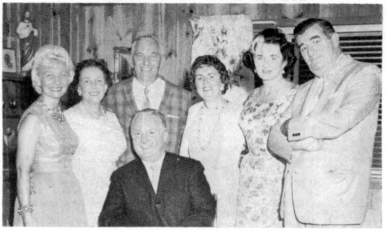

Seated in the foreground is his honor, John F. Collins, mayor of Boston, Mass. Behind the mayor, left to right, are Miss Margaret Eichler, Mrs. George H. Eichler, Mr. Eichler (owners of Hulett's on Lake George), Mrs. Mary Collins the mayor's wife, Mrs. Rose Ellis (President Kennedy's cousin) and William H. Ellis, Jr.

Mr. and Mrs. William H. Ellis, Jr. of Newtonville, Mass. are vacationing again this year at Hulett's on Lake George, the famous cottage colony resort on the east shore, owned by George H. Eichler. Mrs. Ellis, formerly Rose Fitzgerald, is Pres. John F. Kennedy's cousin. Her grandfather and his grandfather were brothers.

Of Lage George, Mrs. Ellis says, "We had such an enjoyable vacation last year, and were so entranced by the beauty of the lake and picturesque Adirondacks, that we decided to return again."

His Honor, John F. Collins, popular Democrat Mayor of Boston, and his wife, Mary, were guests recently at Hulett's of Mr. and Mrs. Ellis.

"Grandeur Like Europe's"

Mayor Collins had recently returned from a "People to People" Friendship Tour through Europe. While there he had an audience with Pope John XXIII. As he approached Lake George via the Hulett's Landing Road, Mayor Collins remarked," The view here is breathtaking and the scenic grandeur is comparable to any of the lakes in Europe."

With Mr. and Mrs. Ellis are their children, William ("Duke") H. Ellis III, 16, and Mary Frances, 7. Mary Frances has been a performer on the weekly talent shows at Hulett's. Mr. and Mrs. Ellis also entertained the Rev. Frank Sweeney, C.S.P. a Paulist priest who has been stationed in Boston. Mr. Ellis, a prominent New Englander, is president and treasurer of W. H. Ellis & Son, Co. New England's oldest pier and bridge construction firm. He is also editor and publisher of the East Boston Free Press, and president of the Board of Trustees of the Boston City Hospital.

The growth of private homes and new houses invigorated and enlivened Huletts in the 1960s. This newspaper story demonstrates that influential people were drawn to Huletts as a vacation destination. (Courtesy of *Lake George Mirror.*)

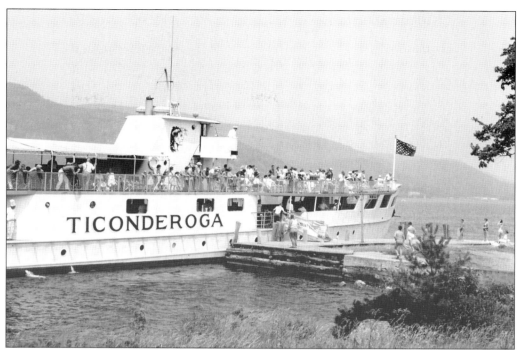

Almost 100 years after it first started landing, the Lake George Steamboat Company stopped daily excursions into and out of the private dock in Huletts Landing in 1964. The *Ticonderoga*, seen above, was the last of the fleet to stop daily. The sign that welcomed so many into Huletts Landing from the lake (seen below) yielded to the automobile and better roads that provided easier access. (Courtesy of Kapusinski collection.)

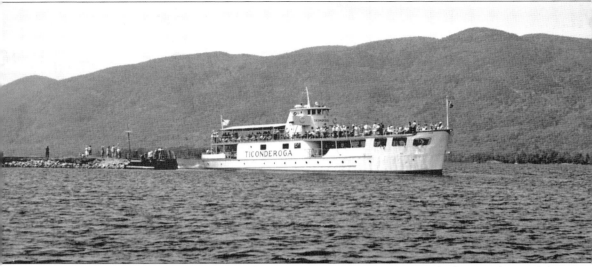

The point at the end of the road would not have any more visitors arrive by boat or ship. While the property was always private, the county sold part of the end of the road also. (Courtesy of Kapusinski collection.)

Mohican Hits Reef Near Huletts Landing; 330 Passengers Unhurt; Vessel to Drydoc

On the night of August 7, 1965, the *Mohican* struck a reef near Huletts and was beached by its captain to prevent it from sinking. Chartered by a Schenectady civic club, the ship was heading south when it ran aground on Whale Rock Reef. The steel hull was punctured in numerous places, and it took in water faster than it could be pumped out. It was able to limp back to Huletts, where it discharged its passengers on the point, before Capt. H. Gordon Burleigh beached it 50 feet from shore to prevent it from sinking. One newspaper account stated, "after landing, the 330 stranded passengers blithely continued partying until early Sunday morning." Two days later, its sister ship, the *Ticonderoga*, towed the *Mohican* back to Lake George Village. (Courtesy of Kapusinski collection.)

With the passing of Mary Wyatt in the late 1960s, the Eichlers would oversee a further restoration of the former Lakeside Inn. Fully converted into a residence by the Wyatts already, the structure was updated and modernized by the Eichlers. (Courtesy of Kapusinski collection.)

The casino remained a focal point for the community. It has always been a popular place for parties and socializing with friends. (Courtesy of Kapusinski collection.)

TALENT SHOW 7/20/67

STACY SMITH * "ROBIN SAT IN A CHERRY TREE"

KEVIN MC NELIS * "DO A DEAR"

KATHY RYAN * CHAMPAGNE

JOEY RYAN * BO-BO

KATHY SMITH * "BARCAROLLE TALES FROM HOFFMAN "

BRIAN MC NELIS * MARY WORE A RED DRESS

KATHY MC NELIS * DANCE

THOMAS GRIFFEN * ACCORDIAN

DANNY NEPHEW

T.T. & MARY

MARY HEALEY

MR.& MRS. STUBER * I BELIEVE
 HAWAIIAN WEDDING SONG

TOM ROSENDAH L "THE TIMES THEY ARE A CHANGING "

MRS. KEOUGH & TOM

Here is the schedule of acts for one of the weekly talent shows held in the casino from 1967. "Talent" was subjective, but the shows were open to all, and the children performers brought people out. (Courtesy of Kapusinski collection.)

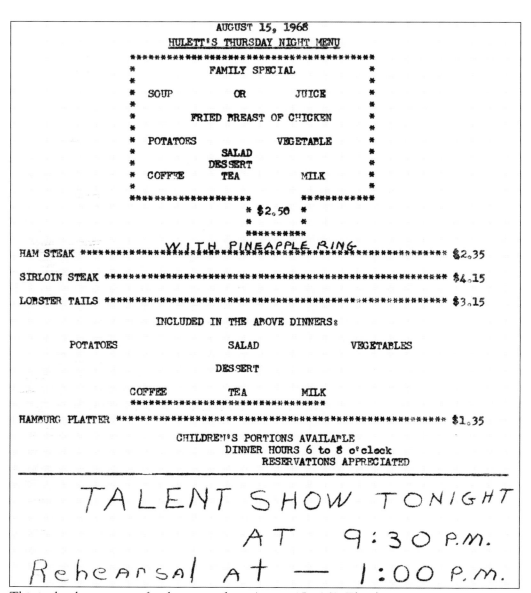

```
                      AUGUST 15, 1968
                 HULETT'S THURSDAY NIGHT MENU
      ***********************************************
      *                  FAMILY SPECIAL              *
      *                                              *
      *    SOUP          OR          JUICE           *
      *                                              *
      *         FRIED BREAST OF CHICKEN              *
      *                                              *
      *    POTATOES              VEGETABLE           *
      *              SALAD                           *
      *              DESSERT                         *
      *    COFFEE     TEA            MILK            *
      *                                              *
      ****************************    **************
                        *  $2.50  *
                        *         *
                        **********
                 WITH PINEAPPLE RING
HAM STEAK *************************************************** $2.35

SIRLOIN STEAK ************************************************ $4.15

LOBSTER TAILS *********************************************** $3.15

            INCLUDED IN THE ABOVE DINNERS:

   POTATOES            SALAD            VEGETABLES

                    DESSERT

        COFFEE         TEA       MILK
        ***************************************

HAMBURG PLATTER *********************************************** $1.35

            CHILDREN'S PORTIONS AVAILABLE
            DINNER HOURS 6 to 8 o'clock
              RESERVATIONS APPRECIATED
```

TALENT SHOW TONIGHT
AT 9:30 P.M.
Rehearsal At — 1:00 P.M.

This is the dinner menu for the casino from August 15, 1968. The dinners were not only good but also inexpensive. This proved to be the perfect recipe for bringing families with children to Huletts. (Courtesy of Kapusinski collection.)

Seven

THE REBIRTH OF HULETTS LANDING

The 1970s and 1980s brought continued change to Huletts Landing. Homeownership increased, but new regulations brought higher property taxes. Homeowners joined together to form homeowners' associations, and long-standing environmental issues were addressed. Throughout it all, the natural beauty of the surrounding area continued to draw multiple generations to the "Huletts experience." Today the future is bright for those who visit and live in Huletts.

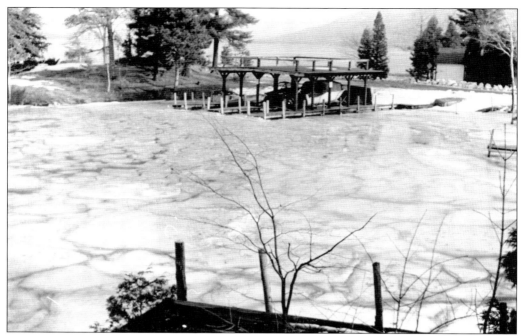

Increased regulations and land use controls were implemented in the Adirondacks in the early 1970s. While growth was curtailed, this caused the tax base of the town and surrounding area to stagnate, causing property taxes to skyrocket. These impending laws actually increased development in the early 1970s because property owners rushed to build before these new laws became effective. (Courtesy of Kapusinski collection.)

Many of the new homeowners in Huletts Landing started forming independent homeowners' associations. Dr. Neil E. Hannan was one of many local homeowners who were instrumental in forming the Huletts Landing Property Owners Civic Association. Having lost a son in a tragic drowning accident in 1967, he focused his energy in a positive direction, going door-to-door explaining how the new association would work. (Courtesy of Kapusinski collection.)

Troy Dentist's Son Drowns At Area Falls

The Labor Day picnic continued as an annual tradition, signaling the end of the summer season. Standing here, from left to right, in 1978 with their golf awards are Huletts residents Patrick Rodgers, John Miller, Kevin Davidow, Neil Hannan, Joseph Boland, Skip Linhart, Tom McElhenny, and Bill Carley. Posed below are Kathy Campbell, Kathleen Fredericks, Chris Hannan, Dot Boland, Carol Hannan, Rosalyn Fox, Maureen Hennessy, and Teri Quick. (Courtesy of Kapusinski collection.)

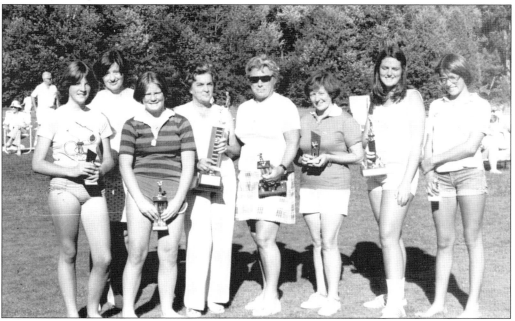

With the deaths of George and Margaret Eichler and their daughter Margot, the Eichlers' son-in-law, Albert T. Kapusinski, assumed responsibility for running and maintaining the bulk of their property. He was instrumental in constructing a new sewer system and having the town assume responsibility for its ongoing maintenance. (Courtesy of Kapusinski collection.)

The annual sailboat races seen here in 1981 were a time of great fun for the community. Multiple generations of families would go on to enjoy the Huletts experience. (Courtesy of Kapusinski collection)

New leach fields were installed underneath the golf course in 1983. Sewer problems that had gotten worse over the years would be solved once and for all with a million-dollar capital improvement to the sewer system. (Courtesy of Kapusinski collection.)

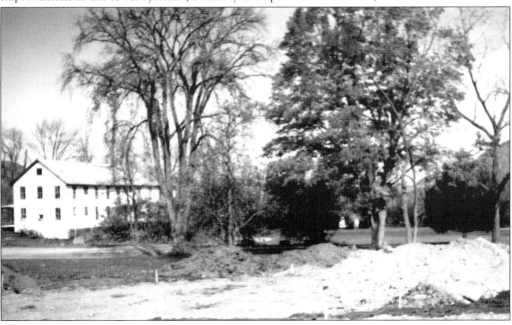

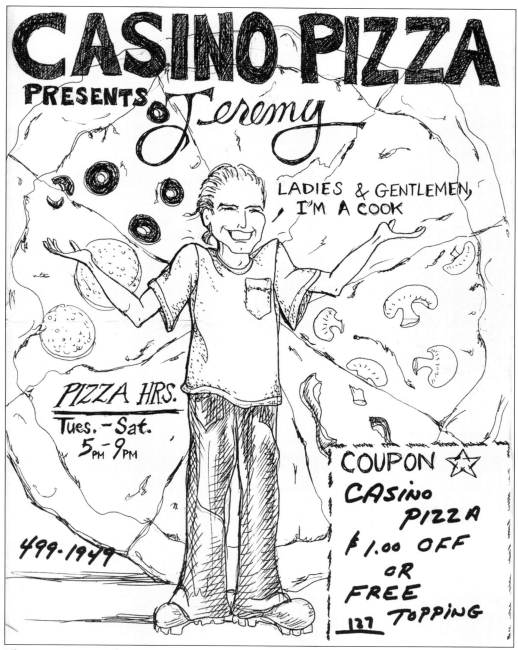

The casino reopened in 1989 after being closed for 16 years. Albert J. Kapusinski spearheaded the reopening of this much-loved establishment, bringing back nightlife to Huletts. (Courtesy of Kapusinski collection.)

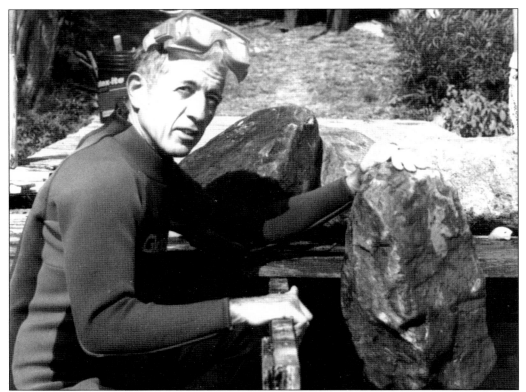

Staff member Edward Briody worked unceasingly during the 1990s to improve the quality of a visit to Huletts. Single-handedly rebuilding docks, tearing down old buildings, and replacing roofs were some of the many things that garnered him the reputation as the Huletts version of Paul Bunyan. (Courtesy of Kapusinski collection.)

Today new houses continue to replace the last vestiges of the old Huletts Landing while keeping the original charm and beauty intact. Nothing signifies the rebirth of Huletts more than new families and new guests enjoying the Huletts experience for generations to come. (Courtesy of Kapusinski collection.)

Eight

LOOKING AROUND

There are places in Huletts that contribute to its charm and appeal. These places add to the allure and magic of the community. The next few pages explore the history surrounding some of these spots. While they sometimes do not get as much attention as the lake and surrounding natural environment, these unique attractions add much to the character of Huletts Landing. While it is difficult to adequately convey the history of all of these sites here, this book would not be complete without including some short descriptions about their origins.

Finally, Huletts has had its share of devastating fires. Because of its rural location, fires, when they have occurred, have spread rapidly and consumed entire buildings quickly. By reviewing a few of the significant fires in the history of Huletts, hopefully this will be an inspiration to be vigilant when enjoying the wonderful natural surroundings of the area.

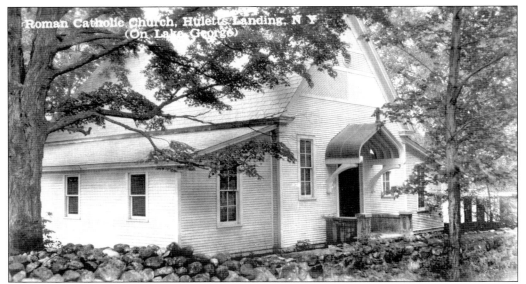

The center section of the Chapel of the Assumption was originally constructed in 1900. Originally two Paulist priests, who were also fraternal brothers, Fr. John Burke and Fr. Thomas Burke vacationed in Huletts with their parents. They stayed at the home of Mr. and Mrs. Nicholas Carroll, one of the few Catholic families residing in Huletts. These priests encouraged the Carrolls and the few Catholics of the area to raise money for a church. (Courtesy of Kapusinski collection.)

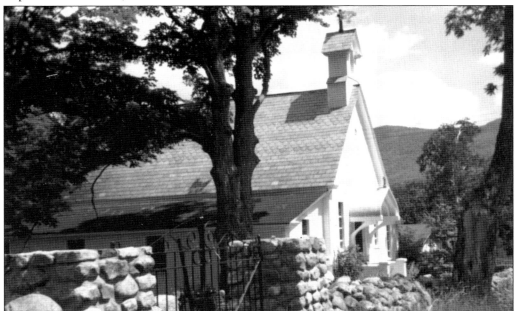

Land was donated by Henry W. Buckell, owner of the Huletts Hotel. The church itself was built by Fr. Peter Moran, who also constructed the small chapel built on Hecker Island, one of the Harbor Islands owned by the Paulist fathers. As time went on, and summer attendance grew, the church was found to be too small for the Sunday crowds. The two side wings were added in 1921. The chapel remains basically unchanged to this day. (Courtesy of Kapusinski collection.)

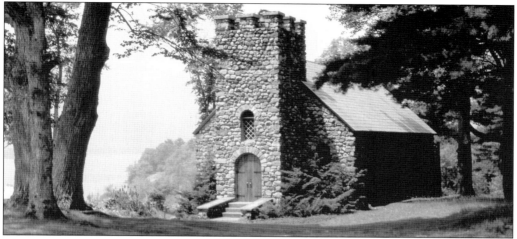

This is the Mountain Grove Memorial Church as seen in 1960. The history of the church started in the 1870s with the efforts of Mr. Condit, Dr. Kimball, and James Kitchel, who traveled the back roads of Dresden in a horse-drawn carriage with a small portable organ. The Mountain Grove Memorial Cemetery was originally the Hulett family's private cemetery. Sunday school was held in Huletts and Clemons. The first Mountain Grove Memorial Church was constructed where Pike Brook Road and the road to Clemons meet. Prior to that, services were held in a grove of hemlock trees a short distance up Pike Brook Road. (Courtesy of Kapusinski collection.)

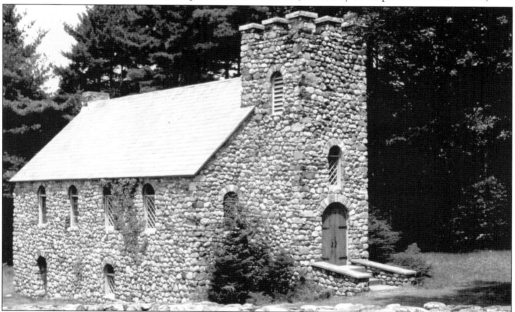

The stone that the Mountain Grove Memorial Church was built from comes from Huletts Landing. On September 17, 1921, a meeting was held and the bylaws for the new church were adopted. It would be named the Mountain Grove Memorial Church of Huletts Landing and would "carry on undenominational work all year round at Huletts." Henry W. Buckell donated the land, and construction started on the stone church in September 1922. It was completed and a dedication service was held on Sunday, September 2, 1923. Visitors to this day marvel at the picturesque little chapel that overlooks the lake. (Courtesy of Kapusinski collection.)

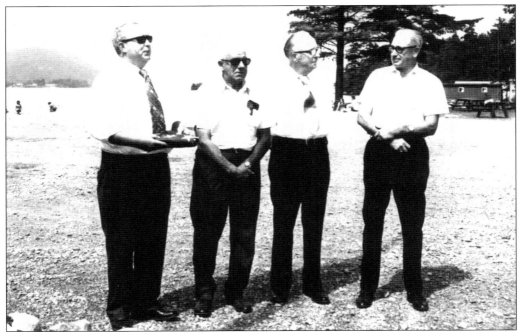

The Washington County Public Beach was dedicated in August 1972. Dresden town supervisor Francis Foster, seen above, was the driving force to make the idea of a public beach a reality. The property was purchased by the board of supervisors in 1971, and it took about a year to enlarge the beach and build a parking area. Picnic tables and tennis courts were installed, and fireplaces were built. The dedication ceremony, when the beach opened, is seen here. The foresight of these elected leaders allowed the public access to Lake George. (Courtesy of the Washington County Archives.)

The Huletts Post Office is usually one of the first things people see when they arrive in Huletts. Seen here in the winter in the 1950s, it is open year-round. Its present location is actually the fourth place it has been located during its existence in Huletts. After moving from the steamship landing in the late 1800s, it was located farther back from the shore near the present-day firehouse and then in postmaster Edward Mann's residence. (Courtesy of Kapusinski collection.)

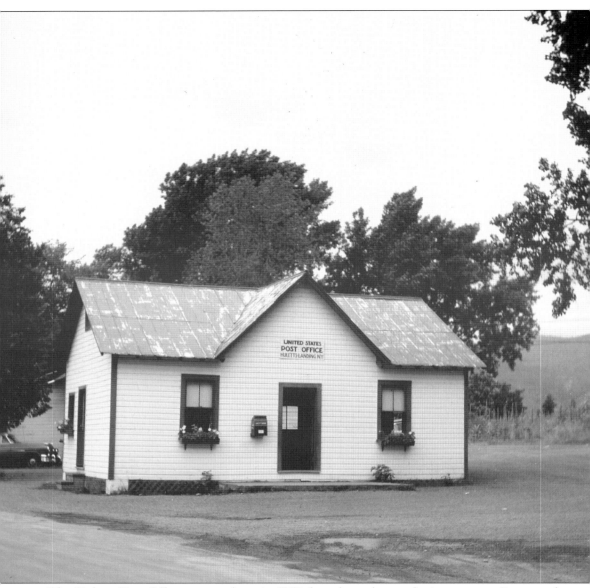

The Huletts Post Office, as seen here in 1960, has always been a basic structure. Renovated numerous times since 1960, it is presently under a long-term lease. It serves as a nice place to say hello to the neighbors while also getting one's mail in the morning. (Courtesy of Kapusinski collection.)

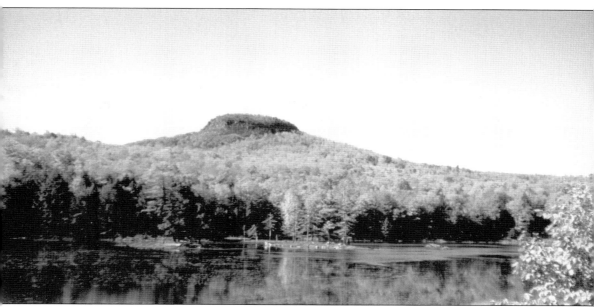

Because of its distinct alive shape, Sugarloaf Mountain is referred to in some of the earliest writings about Lake George. *America Her Grandeur and Her Beauty: Lake George*, from about 1910, relates the following: "Nestling in a beautiful bay dotted with green islands, and at the base of Black Mountain is Hulett's Landing, a place much frequented and very popular with the summer resorter. The fishing in this locality is fine and a splendid bathing beach makes it doubly attractive to those who love the water. From Hulett's charming views are obtained of the rocky heights of Black Mountain and Sugar Loaf, the latter being second in elevation of the great uplifts of the lake George region. The scenery among the islands of this vicinity and along the shores of the various small bays is of pleasing character." (Courtesy of Kapusinski collection.)

There have been a number of notable fires in the history of Huletts Landing. The Pell and Trimboli families' two-family duplex burned to the ground in the early 1970s. While both families would later build individual single-family residences on the parcel in succeeding years, these pictures show the devastation caused by the fire. (Courtesy of Kapusinski collection.)

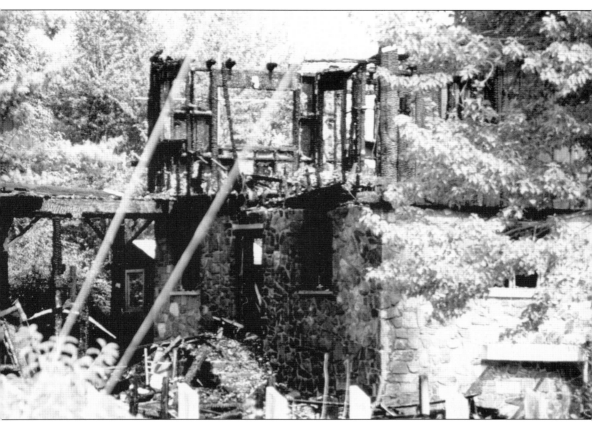

In the early morning hours of August 12, 2001, a fire raged through the Borden residence in Huletts. Luckily, all got out alive before the house was thoroughly consumed. This picture shows the devastation from that night. The Bordens rebuilt their house and hopefully will enjoy many more happy years in Huletts. (Courtesy of Kapusinski collection.)

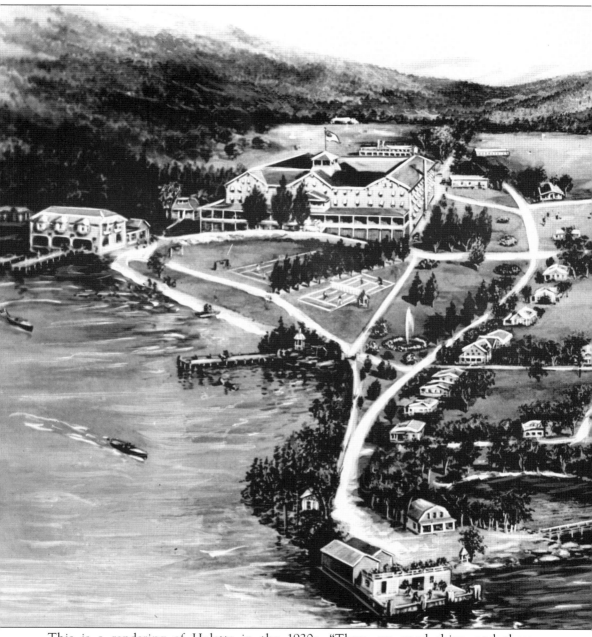

This is a rendering of Huletts in the 1920s. "There are good ships, and there are wood ships, the ships that sail the sea. But the best ships are friendships, and may

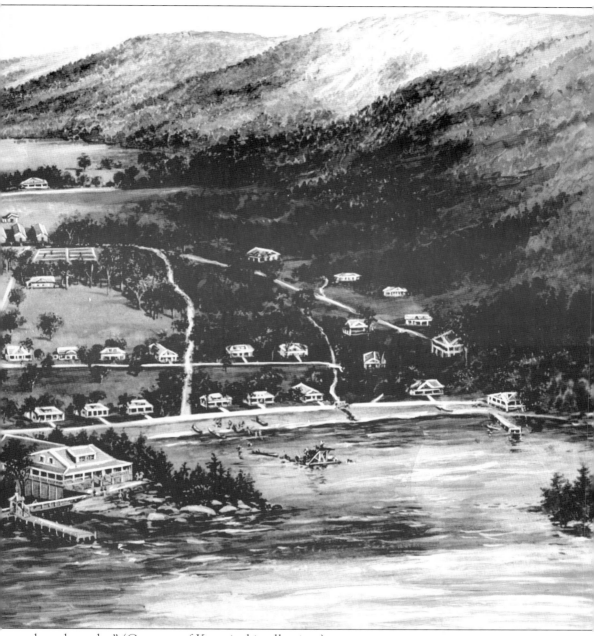

they always be." (Courtesy of Kapusinski collection.)

ACROSS AMERICA, PEOPLE ARE DISCOVERING SOMETHING WONDERFUL. *THEIR HERITAGE.*

Arcadia Publishing is the leading local history publisher in the United States. With more than 3,000 titles in print and hundreds of new titles released every year, Arcadia has extensive specialized experience chronicling the history of communities and celebrating America's hidden stories, bringing to life the people, places, and events from the past. To discover the history of other communities across the nation, please visit:

www.arcadiapublishing.com

Customized search tools allow you to find regional history books about the town where you grew up, the cities where your friends and family live, the town where your parents met, or even that retirement spot you've been dreaming about.